THE POSTCARD HISTORY SERIES

Pekin and Tremont, Illinois

IN VINTAGE POSTCARDS

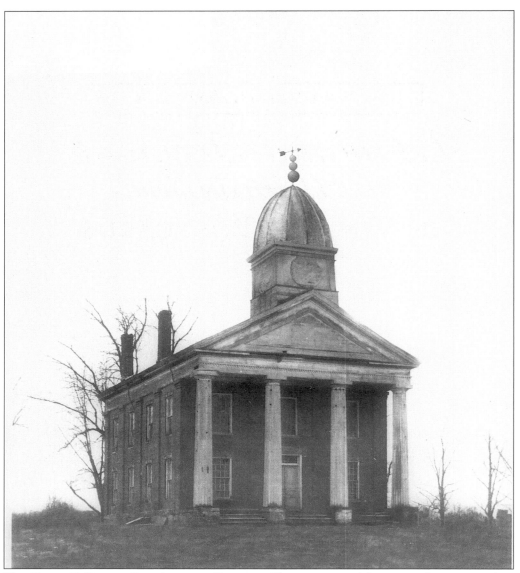

The Tazewell County Courthouse in Tremont, Illinois, pictured here, was first occupied in September 1839. Tremont had been designated county seat in 1836; however, court sessions were initially held in a clerk's office and later in a temporary wooden structure prior to completion of this building. The construction contract was awarded January 13, 1837, to Wm. F. Flagg, who was known as a man of great mechanical skill and had already built courthouses for Putnam and La Salle Counties. Historians note the two-story brick structure was of the Grecian order of architecture; it was ornamented with a cupola and an iron rod supporting three gilt balls. The county seat was returned to Pekin in 1850. Subsequently, Tazewell High School classes were conducted in this building. The upper floor was later used for dances, theatrical productions, and various other community events, and the first floor was finally used for tenements. By the mid-1890s, the once impressive structure, where Abraham Lincoln is known to have tried cases, had fallen into disrepair and was razed c. 1895. This is the only photograph in the book that is not from a postcard. (Courtesy of the Tremont Historical Society.)

THE POSTCARD HISTORY SERIES

Pekin and Tremont, Illinois
IN VINTAGE POSTCARDS

Donald L. Nieukirk

ARCADIA

Published by Arcadia Publishing,
an imprint of Tempus Publishing, Inc.
770 North La Salle Street, Suite 401
Chicago, IL 60610

Printed in Great Britain.

Library of Congress Catalog Card Number: 99-069507

For all general information contact Arcadia Publishing at:
Telephone 843-853-2070
Fax 843-853-0044
E-Mail sales@arcadiapublishing.com

For customer service and orders:
Toll-Free 1-888-313-2665

Visit us on the internet at http://www.arcadiaimages.com

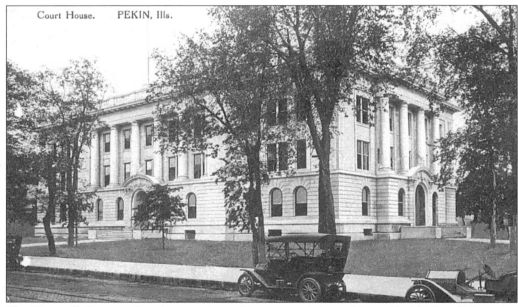

Court House. PEKIN, Ills.

The Tazewell County Courthouse, pictured here, was dedicated June 21, 1916, in Pekin. An earlier courthouse, erected in 1849, stood at the same 300 Block, Court Street site. It was razed in 1914 to make way for this building. The Peoria newspaper dated July 24, 1915, carried a story which reads in part, "Two large derricks in use for the past eight months in the hoisting of material for the courthouse were taken down yesterday afternoon. This indicates that practically all of the heavy material has been taken to the third story. Superintendent Deal remarked that he did not expect the courthouse to be ready for occupancy before the first of May." My mother, who was 16 years old and living in Tremont in 1916, told that her father promised to take his family to Pekin for the dedication ceremonies. Fate intervened and Mom awoke that morning with the mumps! Trip canceled!

CONTENTS

INTRODUCTION

Local history has been of keen interest to me since my teen years, so, collecting picture postcards with their intrinsic historical connotations was a natural outgrowth of early interests.

My wife, Delores, and I have collected such cards for many years and have amassed an extensive collection. In recent years we have limited our acquisitions to local cards. Accordingly, the bulk of our collection is from Pekin, Illinois, my birthplace; neighboring Tremont, where I attended elementary and secondary schools; and Peoria, where we now live.

Over 200 Pekin and Tremont cards have been selected for this book. In an effort to show something of the history of the two communities, I've included cards depicting river scenes, street scenes, early churches, schools, homes, businesses, and other interesting and varied cards. Many of these cards have not been previously published in any of the several printed local histories. Picture postcards, other than real photos, are not 100 percent reliable as a reference for historical research due to the propensity of early artists and publishers to embellish and enhance. Their goal, rather than historical accuracy, was to make the cards appealing and salable. However, early cards do provide revealing windows to the past and are often helpful in furthering appreciation for our rich heritage.

A single cabin, constructed in 1824 beside the Illinois River by Jonathan Tharp, was the inauspicious beginning of what is now Pekin. The settlement grew sporadically through all the ups and downs of a frontier "river town." The city has been the county seat of Tazewell County since 1850 and now has a population of approximately 35,000. Tremont, less than 10 miles eastward, was established in 1835 by a group of colonists largely from New York. They brought with them the culture and desire for education and refinement to which they were accustomed. Tremont prospered in its early years and was the county seat from 1836 to 1850. By that time, Pekin had become a center of commerce, principally due to the access to river transportation, and the county seat was moved there. Tremont's present population is about 2,500, or less than 10 percent of the "river town."

A very enjoyable part of any hobby is sharing your passion, and this book provides an excellent opportunity for such sharing. It was Mr. Micawber in Dickens's "Pickwick Papers" who said, "The scenes and events of the past afford gratifying emotions."

May it be so for you!

ABOUT POSTCARDS

Deltiology, a word coined by Randall Rhoades of Ashland, Ohio, in the 1930s has become the accepted term for the study and collection of picture postcards. Accordingly, one interested in these pursuits is called a deltiologist. The collecting of postcards was a very popular hobby in the early 1900s. It is recorded that sales for the year 1906 in the United States alone totaled nearly 800 million, and by 1913, sales were very close to 1 billion annually.

The Golden Age of the postcard is generally agreed to span the period 1898 through the middle of World War I, when the German printing facilities became inaccessible. A large percent of postcards in those heyday years was printed in Germany because of their advanced lithographic techniques. The United States Post Office first issued postcards in 1873. Some European countries, notably Germany and Austria, were issuing cards a few years earlier. The Private Mailing Card Act of May 19, 1898, allowed the general public to mail privately published cards for 1¢, same as the government cards. These PMC's, as collectors call them, were required by law to have the words Private Mailing Card printed on the back to distinguish them from USPO cards. Initially, the back on all cards was reserved for the address, and any message had to be written on the face of the card, sometimes in a very small space. In 1907, the USPO allowed written messages on the back along with the address, hence, the first of the divided back cards. An example of the PMC is shown on page ten.

The first really successful marketing of picture postcards in the United States was by Charles W. Goldsmith. He issued and distributed cards with multi-colored views from the Columbian Exposition in Chicago in 1893. Two examples of these cards are shown on page nine. After World War I, most of the cards sold in this country were also produced here. Cards produced after c. 1915 can be categorized for convenience in referencing by the terms that follow. Of course, the dates are generalizations.

White Borders (1915–1930) During this period, many of the cards printed in the United States had a small white border on all four sides of the image. Several of the cards in this book are of this type (with the border cropped at the scanning stage).

Linens (1930–1945) These cards have a rough finish, some say resembling linen, and were made from paper with a high rag content.

Chromes (1945–present) These cards are printed mainly in vivid colors, and most look like a photograph made from a color slide.

C.U. Williams of Bloomington, Illinois, was a very well-known publisher and distributor of picture postcards in the early 1900s. He was a very good photographer and traveled the country taking pictures for his cards. Several are included in the Tremont section of this book and are so identified. One of his advertising cards indicating a sales price as low as $3.50 per thousand for

his stock appears on page ten.

Deltiology in recent years has once again gained great popularity as a hobby. There are deltiology clubs in many major cities across the country. These clubs sponsor large, well-attended shows where cards are displayed, traded, bought, and sold. Collectors may also purchase monthly periodicals devoted exclusively to the subject.

If you are looking for a hobby, deltiology may be just the thing for you.

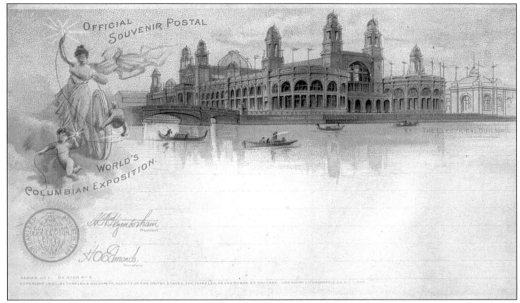

This is one of Charles W. Goldsmith's multi-colored picture postcards issued for the Columbian Exposition in Chicago in 1893. It shows the Electrical Building and is identified as Series No. 1, Design No. 5.

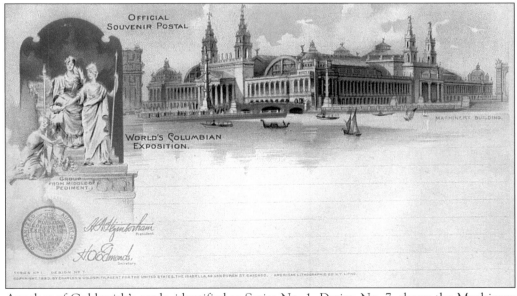

Another of Goldsmith's cards, identified as Series No. 1, Design No. 7, shows the Machinery Building. On the back of these cards in the upper right corner is a circular picture of General Ulysses S. Grant surrounded by a leafy wreath.

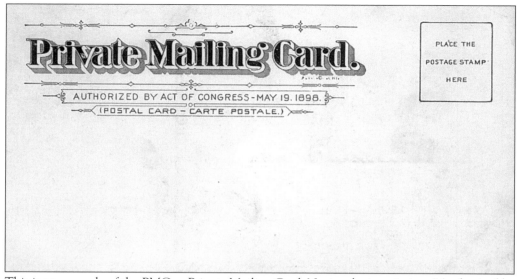

This is an example of the PMC or Private Mailing Card. Notice the inscription, "Authorized by Act of Congress—May 19, 1898." Also the back is undivided indicating any message was to be written on the face of the card.

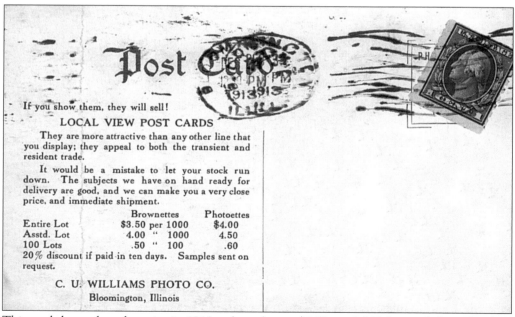

This card shows the sales price in 1913 to be as low as $3.50 per 1,000 for stock from the then popular C.U. Williams Photo Co., Bloomington, Illinois.

One

DOWN BY THE RIVERSIDE

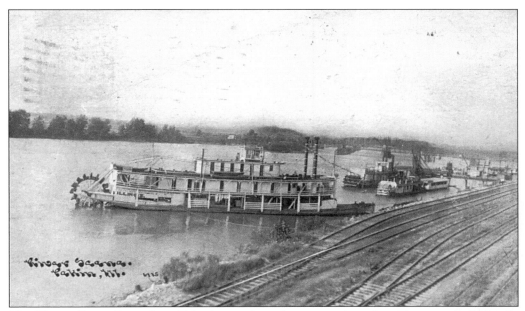

The Illinois River flows along Pekin's west boundary approximately midway on its 273-mile journey through the state. The river has its origin in the northeast corner of Grundy County about 40 miles southwest of Chicago. It is formed by the confluence of the Kankakee and Des Plaines Rivers. The Illinois flows almost due west for nearly 100 miles, turning south near Depue. Then it continues on a southwestern course to join the Mississippi near Grafton, Illinois. It was at this point that Father Jacques Marquette and his companion, explorer Louis Joliet, discovered the Illinois River in 1673 on an exposition sponsored by the French government in hopes of finding a water route to the Pacific. Near this merging of streams at Grafton is Pere Marquette State Park, Illinois' largest state park, and a large white stone cross, which marks the spot where Marquette and Joliet entered the Illinois in 1673. The park and monument are meant to honor and make permanent the remembrance of the feat of these brave men. The steamer Illinois shown on this card was owned by the Illinois Waterways Commission and was frequently stationed at Pekin.

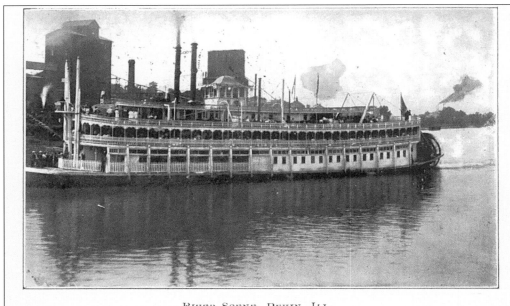

RIVER SCENE, PEKIN, ILL.

This scene on the Illinois River shows passengers boarding one of the large steamers which frequented Pekin. Taking a ride on an excursion steamer was a very popular social pastime in 1908 when this card was posted. Unfortunately the name of the vessel cannot be determined.

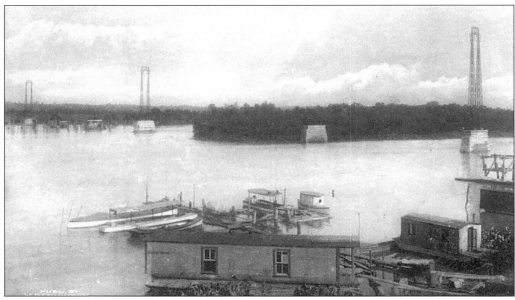

Here is another Illinois River scene at Pekin. The water level appears to be quite high; no date is indicated on the card. Steel towers carrying electric power across the river can be seen in the background.

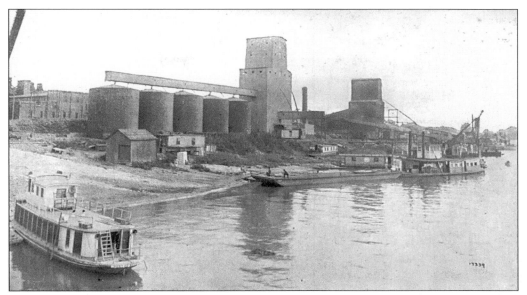

The 1909–1910 Pekin City Directory identifies these two grain elevators as the Turner-Hudnut Elevator at 15–19 Front Street and the Smith–Hippen Company at 107–109 Front Street. The former with a 75,000-bushel capacity was destroyed by an arsonist's fire in 1910 (see page 85), and the latter was torn down many years ago. Other elevators currently stand at approximately the same location. The open area at left is the west end of Court Street.

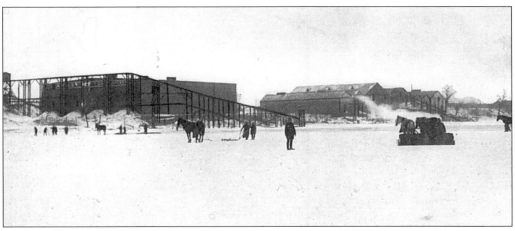

Shown here are the ice houses of W.A. Boley Ice Company, Inc. The name Boley appears on the building at far left. The workmen are cutting and hauling ice from Pekin Lake with horse-drawn equipment. The chunks of ice could be stored for two years without significant deterioration. Large shipments were sent down river on barges for southern markets. Pekin Lake, which may be seen along State Route 29 north of Pekin, is much more shallow today than in the heyday of the ice industry, when this picture was taken.

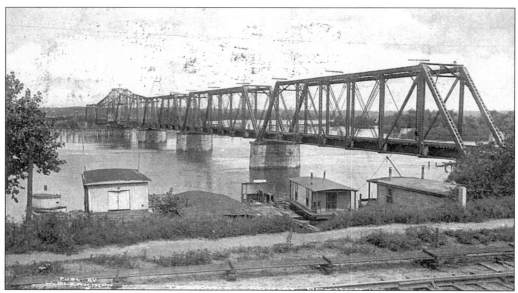

This bridge was built to bring the Peoria and Pekin Traction Company tracks into Pekin. It was opened to rail traffic March 5, 1900. In 1906 the company name was changed to Peoria Terminal Company, hence the name Terminal Bridge. It was destroyed in the early 1970s to make way for the present highway bridge.

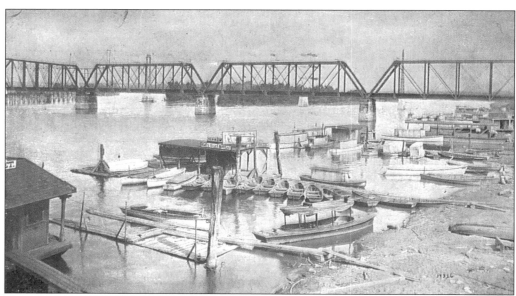

The Terminal Bridge and Cooper's Island are shown in the background of this photo. Some sources refer to the island as Carey's Island. It is recorded that Charles Carey leased a river ferry for one year in October 1857, and it's feasible that it could have borne that name at one time. The sign on the center building, housing Bush's Fish Market, reads, "minnows for sale and boats to let." The card was posted in 1926 and the message is in German.

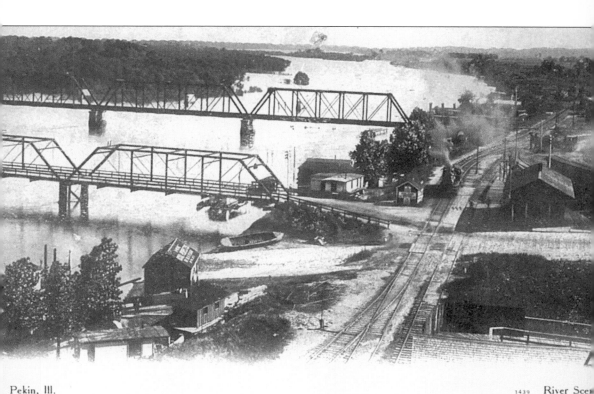

Pekin, Ill. 1439 River Scer

The bridge in the foreground, known as the wagon bridge, was built in 1904. The floor was made of wooden planks. It is recorded that over 14,000 buggies and nearly 22,000 wagons crossed the bridge in one month during 1911. The structure was destroyed to make way for the 1930 bridge. The Terminal Bridge is in the background. This card, as well as several others in this book, was published by prominent Pekin merchant William Blenkiron, who owned and operated a bookstore for nearly 40 years. He was born in Yorkshire, England, in 1830 and settled in Pekin in 1858. In early years he was an instructor at Jubilee College and later taught in Pekin. He was high school superintendent when the 1868 school building was erected on Washington Street. He was also known for his athleticism; he pitched for the first baseball team Pekin ever had and was seldom defeated. Blenkiron was also an excellent cricket player in Canada and his native England. He died in Pekin at age 87 in 1917. There is a neighborhood park named in his honor.

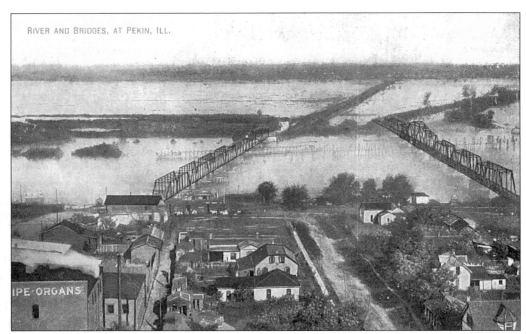

IPE·ORGANS

Another view of the wagon bridge and the Terminal Bridge appears on this card, which was also published by William Blenkiron. The water level is quite high! Date cannot be readily determined as the card was never mailed. Notice the Hinners Organ building at lower left.

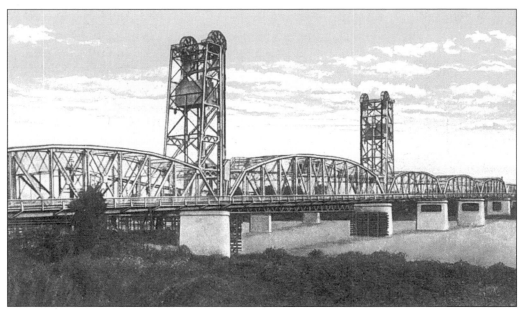

This newly constructed bridge was opened to traffic in early 1930. The of January 12, 1930, headlined, "An Engineering Feat Never Before Accomplished." The article continued, "The 900,000 pound (450 ton) lift span of the new Pekin bridge was floated into position on five immense barges." The span was replaced by a multi-million-dollar four-lane superstructure completed in 1982, the John T. McNaughton Bridge. (Courtesy of Dean Bacon.)

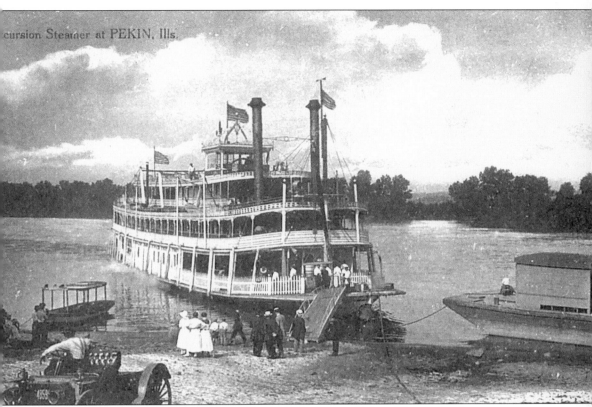

Pictured here c. 1916 is the steamer Columbia docked at Pekin. The Columbia was a very popular excursion boat travelling the Illinois River out of the port of Peoria from 1911 to 1918. She was three decks tall with long walkways alongside the cabins. The wooden boat was built c. 1898 and spent some time on the Mississippi River before being moved to this area. In September and October 1917, the vessel was rebuilt and upgraded for the third time. At that time, federal inspectors described the Columbia as, "the safest boat on western waters." It was licensed to carry 1,000 passengers with an additional 200 permitted when towing its barge, Summer Girl. The vessel was owned by H.F. Mehl.

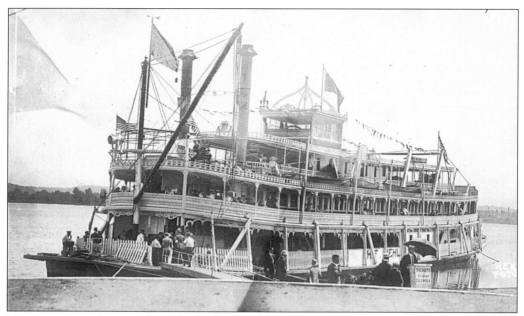

Here's another photograph of the Columbia. Note the stand at lower right where excursion tickets are being sold. Pekin's South Side Social Club sponsored a holiday excursion for July 4, 1918, to Al Fresco Park north of Peoria. En route from Kingston Mines, the boat left Pekin at 8:15 p.m. with nearly 500 excursionists aboard. After a delightful time at the amusement park, the destination for many previous trips, the ill-fated steamer began her homeward journey.

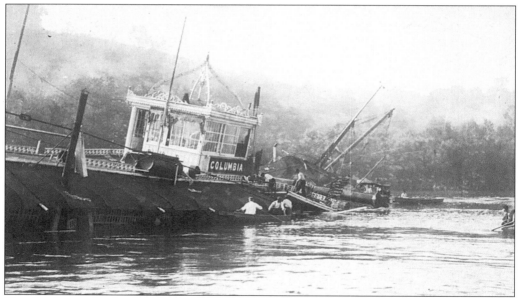

Shortly after midnight, July 5, 1918, just a few miles upstream from Pekin, tragedy struck. The steamer Columbia struck a submerged log or stump which tore a great hole nearly 12 feet long in her hull as Captain Herman F. Mehl backed the boat away from where it was stuck into deeper water.

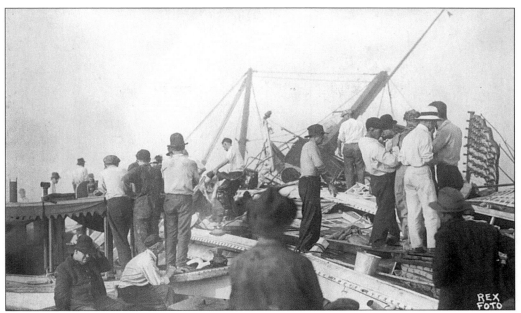

These cards show the wreckage and the macabre effort to recover bodies. A makeshift morgue, where the dead could be identified and tagged, was hastily arranged in Pekin. Of the nearly 90 people killed in the catastrophe, most were Pekin residents; however, some were from Kingston Mines and Peoria.

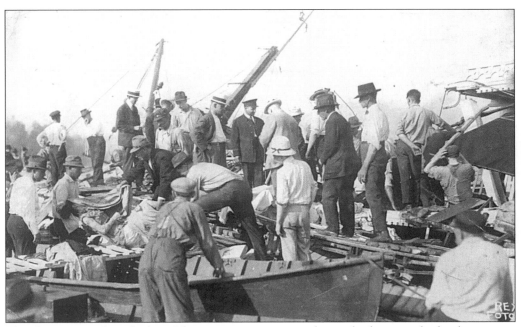

The disaster was described as, "the most tragic catastrophe in the history of inland waterway navigation in the United States." The injured were taken to both Pekin and Peoria hospitals. Eighty-seven lives were lost.

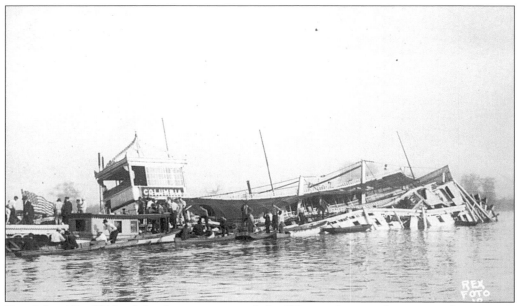

On July 17, 1918, federal inspectors ruled, "No evidence of unseaworthiness was found—improper seamanship and that alone was responsible for the heavy loss of life." Captain Mehl and his pilot, a Mr. Williams, both lost their navigation licenses. I have 20 different cards in my collection showing this disaster; those included in the book are a good representation.

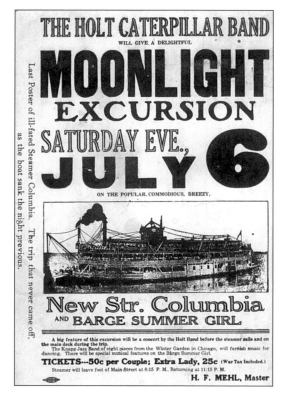

This card was made from a poster advertising an excursion by the steamer Columbia and her barge, Summer Girl. The outing was scheduled for July 6, 1918, and was to leave from Peoria's dock at the foot of Main Street. It never happened as the once majestic steamer lay on her side broken in pieces just a few miles downstream.

Two

LET'S GO TO CHURCH NEXT SUNDAY MORNING

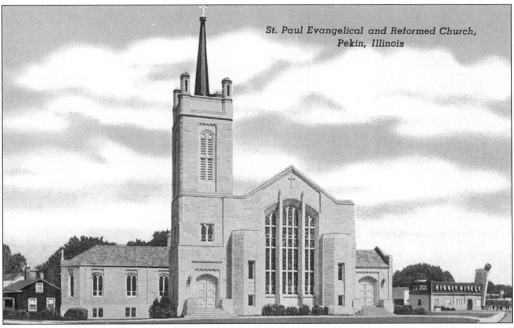

St. Paul Evangelical and Reformed Church,
Pekin, Illinois

This Gothic-style building was dedicated in 1953 as the St. Paul Evangelical and Reformed Church. It stands at 101 North Eighth Street and is presently known as St. Paul United Church of Christ. An education wing was added in 1966. The church's Austin organ with 33 ranks of pipes was installed in 1982 and is the largest pipe organ in the city. The church was organized in 1858 under the name St. Paul German Evangelical Church, and all services were conducted in German. The early Sunday morning service was in German as late as the early 1940s. I recall attending there with my grandparents, Mr. and Mrs. H.A. Nieukirk, and enjoying the hymns being sung in German as we waited in the narthex to be seated for the English service to follow. (Courtesy of Dean Bacon.)

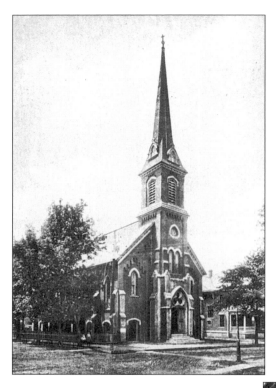

This St. Paul Evangelical Church was erected in 1877 on the southwest corner of Ann Eliza and Seventh Streets, the same site as an earlier building of the congregation. The structure shown was razed in 1953 when the new church (see page 21) was completed. The old cornerstone has been preserved and displayed on the grounds and affirms the construction and organization dates with this German inscription. "Kirache Erbaut 1877, Gemeinde Gegrundet 1858."

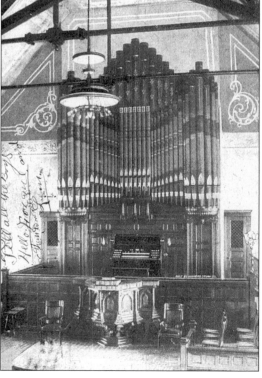

This is an interior view of St. Paul's German Evangelical Church pictured above. The focal points are the Hinners organ including elaborately decorated pipes and the ornately carved pulpit. The organ was dismantled and sold when the new church was built in 1953.

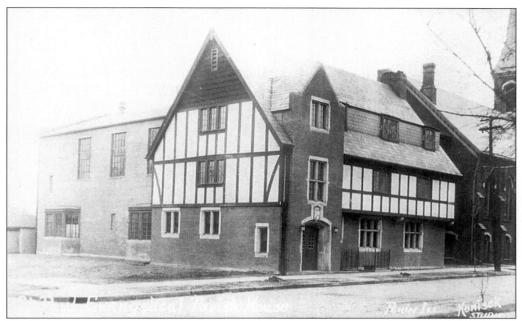

St. Paul Evangelical Parish House was dedicated February 28, 1926. It has been used for many social functions of the church as well as for numerous nondenominational civic events. It stands at 103 North Seventh Street across the street from the present church facility.

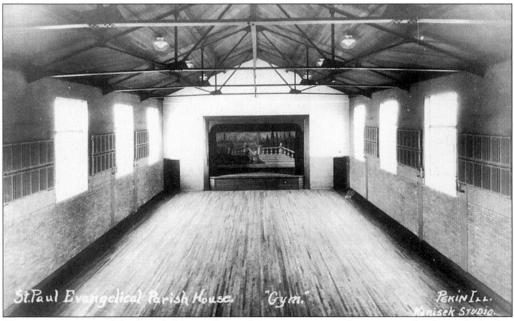

This interior view of the Parish House shows the gymnasium with a stage at the far end. At this writing the building is in poor condition and closed for safety precautions. Its future is uncertain.

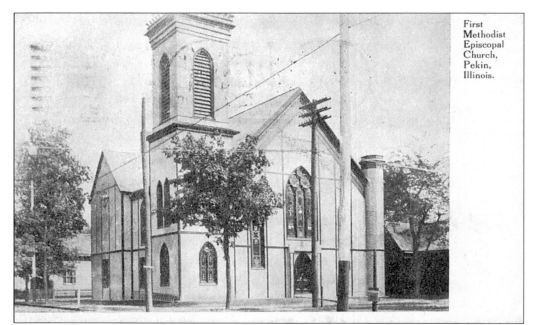

First Methodist Episcopal Church, Pekin, Illinois.

The First Methodist Episcopal Church was organized in Pekin in 1826. It was the first organized religious body in what is now Pekin. In the beginning, services were held in the log cabin home of Jacob Tharp. The stuccoed wooden structure pictured here was erected in 1867 at the corner of Broadway and South Fourth Streets. It was referred to as the English Methodist to distinguish it from the German-speaking congregation across town.

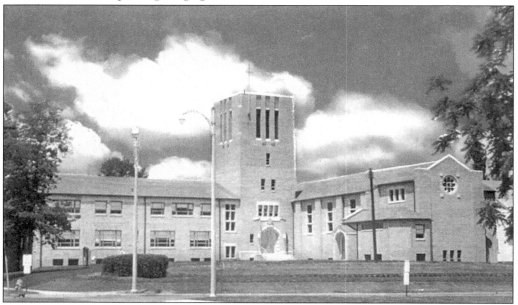

This First Methodist Church (Episcopal was dropped from the name in 1939) was completed in 1954. The former church building at Broadway and South Fourth Streets was razed at that time. The new church has beautifully landscaped grounds and overlooks Mineral Springs Park Lagoon. The name, since 1968, has been First United Methodist Church.

Pictured here is the German Methodist Episcopal Church built in 1874 at the corner of North Fourth and State Streets. This church installed the first pipe organ in the city, Hinners, of course. The structure was destroyed by fire December 6, 1911. Services were held in the courthouse awaiting completion of a new church. After the fire, metal was salvaged from the old church bell for making little souvenir bells, which were sold to help cover the cost of a new bell. (My wife has one in her bell collection.)

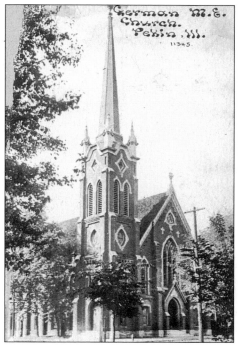

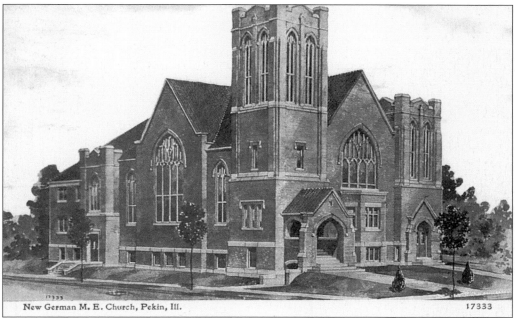

New German M. E. Church, Pekin, Ill. 17333

The German Methodists built their new church on the same site as the one that burned. The congregation marched from the temporary sanctuary in the courthouse to the new church singing "Onward Christian Soldiers" in 1914. By that time, English services were conducted and German was phased out. The name has evolved to the present Grace United Methodist Church. The church has a three manual Hinners organ and a 1500 pound bell cast by Meneely Foundry of Troy, N.Y.

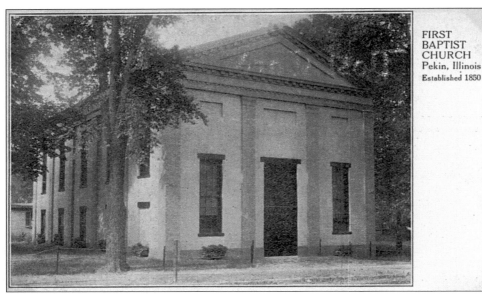

FIRST
BAPTIST
CHURCH
Pekin, Illinois
Established 1850

The First Baptist Church in Pekin was organized in 1850. In 1852, a reorganization was recognized by the church council. It is recorded that Rev. S.S. Martin of Tremont was present at the reorganization meeting. Work on the structure pictured in this postcard was completed in 1855. Abraham Lincoln, a friend of Pastor G.S. Bailey, gave a "liberal sum of money for the Baptist Church of Pekin." It is noted elsewhere that this "liberal" contribution to the building fund was $10.

The Congregational Church in Pekin was organized in 1909. The building stood at the junction of South Sixth, Broadway, and Elizabeth Streets and was dedicated Easter Sunday, April 16, 1911. The structure was razed in the early 1970s.

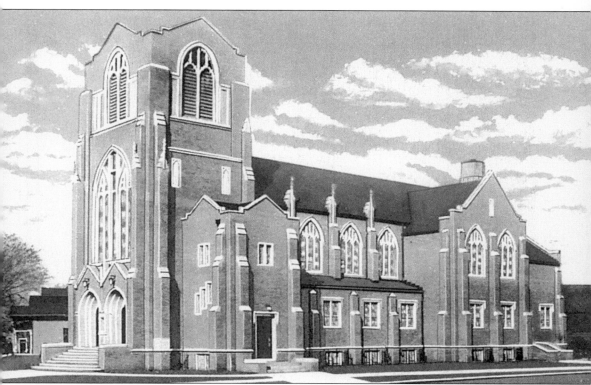

St. John's Lutheran Church, another of the local churches to be founded by German immigrants, was organized in 1852 using the name St. Johannes Evangelical Lutheran Church. Initially services were held in members' homes; of course, the sessions were conducted in German. The first pastor was from Hamburg, and it was not until the summer of 1917 that some services were held using English. Gradually the German was phased out. The congregation's first building was erected in 1853 at Fourth and Ann Eliza Streets. In 1871, another building was built across the street from the earlier structure. The building pictured is of Gothic design and stands at 711 Court Street. It was dedicated the week of February 20–27, 1927. An education wing was added in 1956. (Courtesy of Dean Bacon.)

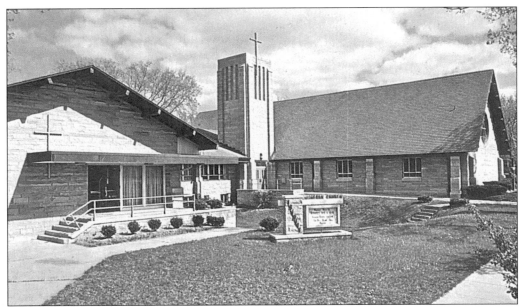

Trinity Lutheran Church (Missouri Synod) was organized in September 1941 by a group that withdrew from another local Lutheran congregation. A simple frame building was completed in time for the Christmas Eve service that year. This present structure was dedicated October 26, 1952, and stands at 700 South Fourth Street. A large circular stained-glass window beautifies the sanctuary. (Courtesy of Jim Deverman.)

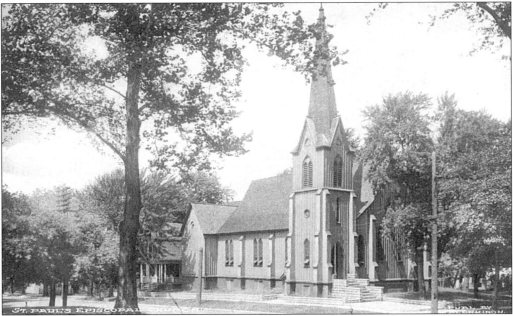

St. Paul's Episcopal Church in Pekin was founded in 1837 with earliest services being held in a schoolhouse. Pioneer church leader, Reverend Wm. Douglas, reported at the diocesan convention in Rushville, Illinois, in June 1838, "I commenced ministering to the spiritual wants of Christ Church, Tremont in conjunction with Pekin."

St. Paul's Episcopal Church stands at 411 Washington Street, the corner of Washington and Buena Vista Streets. The church was first occupied in 1876 and has been well maintained with extensive remodeling, redecorating, and improvements throughout the years. (Courtesy of Jim Deverman.)

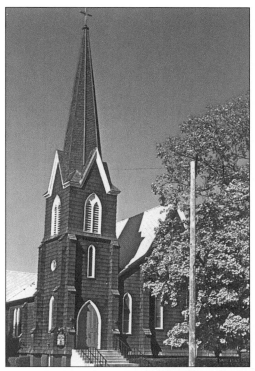

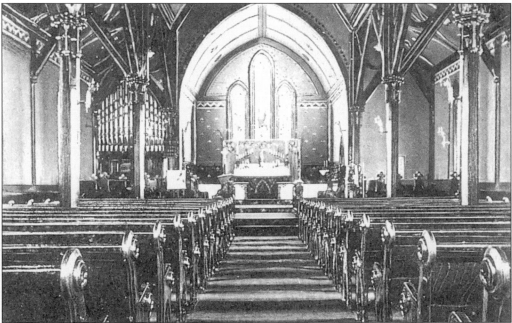

Pictured here is an interior view of the St. Paul's Episcopal Church. The card is dated 1913 and shows the sanctuary to be exquisitely appointed. The organ pipes at left are from an early Hinners organ. A newer organ console is now located on the opposite side of the altar area.

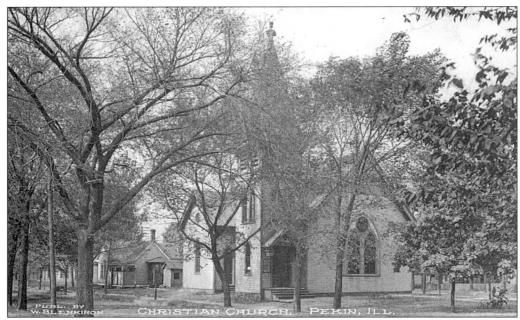

First Christian Church (Disciples of Christ) was established in Pekin in 1876. This frame building, their first, stood at the corner of Broadway and Elizabeth Streets and was dedicated November 18, 1883. The building was sold in 1953 and was used by other denominations until it was razed c. 1974. First Christian's present building at 1201 Chestnut Street was dedicated in 1953.

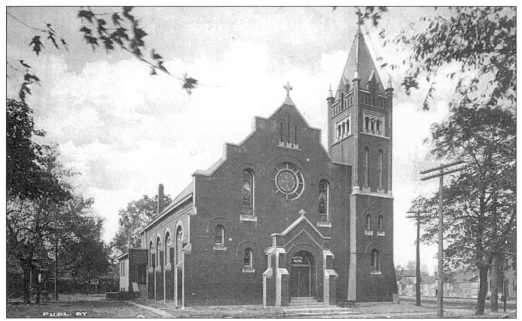

This St. Joseph's Catholic Church building was dedicated October 1904. It stood at the corner of Broadway and South Seventh Streets. A new church and rectory were built on the same site in 1968. The new structure is of Bedford stone, brick, and concrete and has a 70-foot bell tower.

Three

SCHOOL DAYS

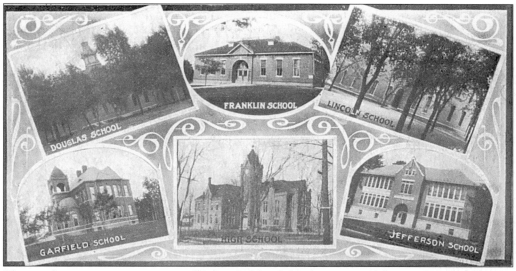

This card, a six-view composite of Pekin Public Schools, was posted in 1906. The Douglas School, first occupied in 1882, was built at 1000 Broadway Street between Tenth and Eleventh Streets. The Tharp Cemetery was previously on this site and as a result, ghost stories were often heard about the school. Many will also recall the Douglas Dads' Minstrel shows. The building was demolished in 1988 and the site has since been commercially developed. Franklin School was built in 1899. It still stands at Second and Broadway Streets, but has not been used as a school for many years. The Lincoln School, Garfield School, Jefferson School, and early high school are individually highlighted elsewhere in this chapter. This and several other cards in the book were distributed by Ferd C. Pauley. He is listed in Pekin City Directories from 1902 through 1909 as a druggist and pharmacist. His shop was initially at 346 Court Street and later at 16–18 South Fourth Street.

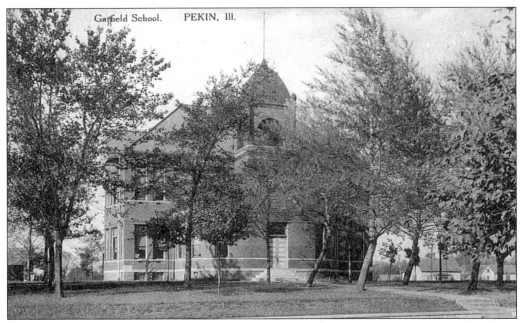

The Garfield School was erected in 1895 at a cost of $8,000. The two-story brick school building was located at 1115 State Street and was named for a president (James A. Garfield) as was the custom then. In 1929–1930 a substantial addition was completed to augment the original four rooms.

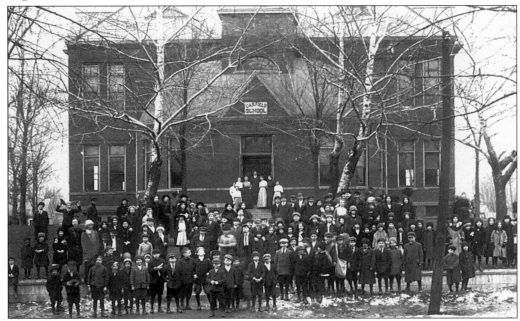

This photo shows Garfield School building and students. The card was never mailed so we cannot look to a postmark for a clue as to date. No names are available. The school was demolished in mid-to-late 1980s, and a Pekin Park District neighborhood park now occupies the spot.

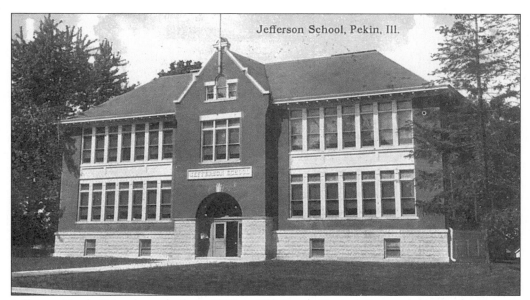

Jefferson Grade School was built in 1905 at 900 South Capitol Street. Additional space was added in 1924 and an extensive renovation was undertaken in 1953. The structure was demolished to make way for the new Jefferson School, which opened for the 1976 fall term at the same location.

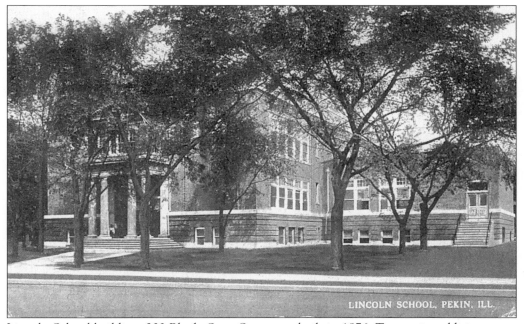

Lincoln School building, 300 Block, State Street was built in 1876. Two major additions were added, one in 1887 and the second in 1901. The building, no longer used as a public school, is owned by neighboring Grace United Methodist Church. Currently the structure houses a Lutheran parochial school and preschool.

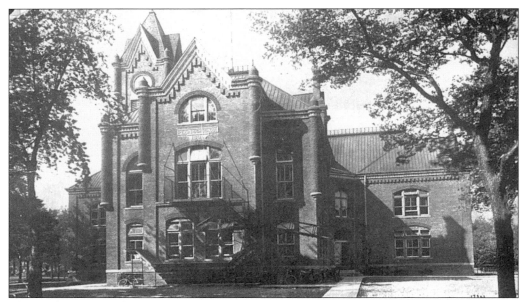

This card is captioned, "Washington School, Pekin, Illinois." The school was built immediately after the previous high school burned in December 1890. Chiseled over the entranceway was "Pekin High School, 1891," even though it housed both grade and high school initially. It stood at Sixth and Washington Streets, site of the present Washington Grade School. The card is postmarked 1915.

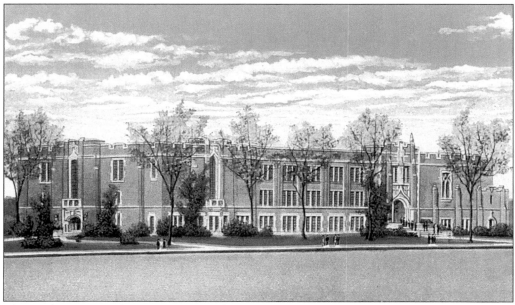

This card is captioned, "New Junior High School, Pekin, Ill." It was built in 1930 at a cost of $350,000 on the same site as the previous Washington School. The building has undergone numerous renovations and additions and is known now just as the Washington School where the middle grades have classes.

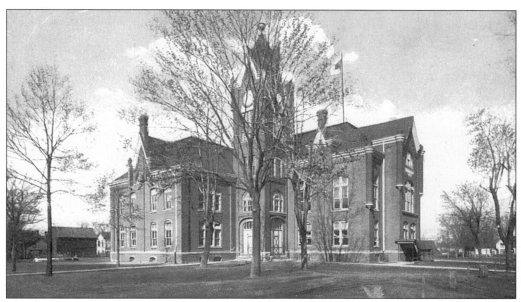

This card postmarked 1913 is captioned, "Pekin High School, Pekin, Illinois," even though it is the same building as shown across the page. Grades 1-12 were conducted here until 1916 when a new high school (West Campus) was erected. The building pictured then became known as Washington Junior High School. It was razed in 1930 when a new junior high school was built on the same site. (See previous page.)

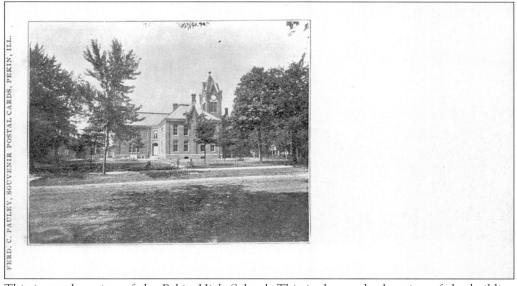

This is another view of the Pekin High School. This is the south elevation of the building shown above. This card was distributed as part of a series by local druggist Ferd C. Pauley. (See page 68 for another example.) Space for the message is provided on the front of the card with the back being reserved for address only. This indicates the card was published not later than 1907.

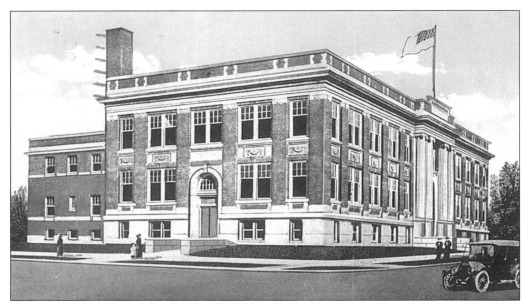

This card is captioned, "New High School, Pekin, Illinois." The building was erected in 1916; however, there was a major addition constructed in 1929, which likely accounts for referring to the school as "new" on this card postmarked in 1929. The building was known as West Campus after the erection of an additional high school (East Campus) in the early 1960s.

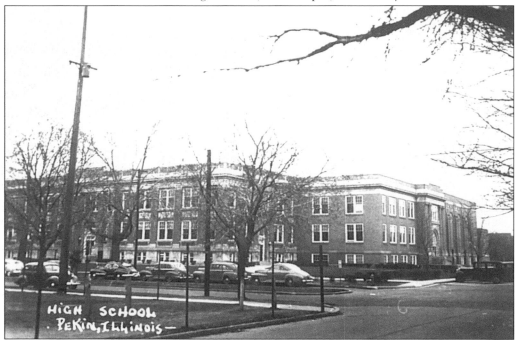

This card shows the expansion of the 1916 high school facility. The original portion faced Broadway between Eighth and Ninth Streets. The entrances were marked above the doorways as "Boys Entrance" and "Girls Entrance." The school was closed in the spring of 1998 as further expansion was undertaken at East Campus.

Four
DOWNTOWN–PEKIN

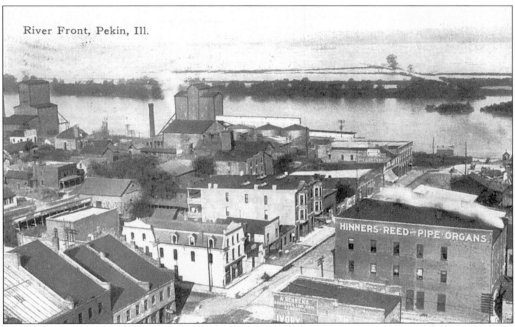

River Front, Pekin, Ill.

Shown here on Court Street leading to the river is the Hinners Organ Company Building. According to Orpha Ochse's, "The History of the Organ in the United States," John L. Hinners came to Pekin in 1879. He worked two years for a local reed organ builder and then opened his own business. After partnerships with J.J. Fink and later U.L. Albertsen, the firm incorporated in 1902 under the name Hinners Organ Company. Initially the company built small organs along standardized patterns, which were sold to small churches at favorable prices. It has been said that Ford brought the passenger car to the common man while Hinners brought the pipe organ to the small church. Tracker action organs were the company's mainstay, although tubular-pneumatic and electro-pneumatic instruments were also made. The company's catalogues were printed in both English and German. At Hinners's death in 1906, his son, Arthur, became company president. The firm had 97 employees in the peak year, 1921. The business closed in 1936, and the building was razed several years ago. The message on the back of this card reads in part, "This town is all German people."

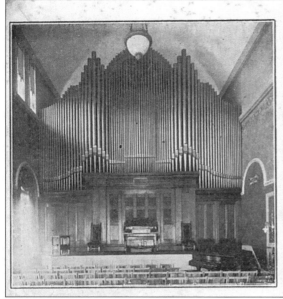

HINNERS PIPE ORGAN

in *Illinois Building, Panama-Pacific International Exposition, San Francisco.*

The following expressions concerning the Organ have been received by the builders:

Clarence Eddy, Concert Organist:—"*Accept my congratulations upon the excellence of your organ on which I had the honor of giving the inaugural recital at the dedication of the Illinois State Building. The organ gives universal satisfaction.*"

Dr. Maurice W. O'Connell, Official Organist Illinois Bldg.:—"*I am delighted with the beautiful design and sweet tone, as well as effective action and convenient appliances of your organ. The immense audiences attending the recitals bear witness to the great success achieved by you in Organ Construction.*"

Mr. Guy Cramer, San Francisco Representative Illinois Commission:—"*Every organist who has played on the magnificent organ erected by your company has praised most highly the merits of the instrument. It has proved to be one of the real features of the Exposition.*"

ESTIMATES ON PIPE ORGANS OF
ANY SIZE CHEERFULLY SUBMITTED

HINNERS ORGAN COMPANY
PEKIN, ILLINOIS

EST. 1879

The large Hinners organ (four manuals, 7,000 pipes) built for the Illinois Building at the Panama-Pacific International Exposition in San Francisco in 1915 is shown on this card. During the run of the fair, nearly 300 recitals were played on the grand organ. The distinguished recitalists included French organist and composer Camille Saint-Saens and Englishman Edwin Lemare, who was billed as the world's greatest living organist.

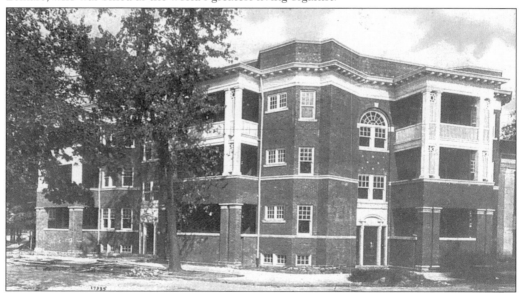

This card was mailed in 1913 and the caption identifies the picture as, "The Curran Apartment House." Built c.1911, the building is more familiarly known as the Buena Vista Apartments. The building stands on Buena Vista Street and the words "Buena Vista" are chiseled above the main entrances. Perhaps Curran was the name of the original owner. Judge William Reid Curran was a prominent Pekinite at the time it was erected. Joanne Baer of Tremont owns the complex at the time of writing.

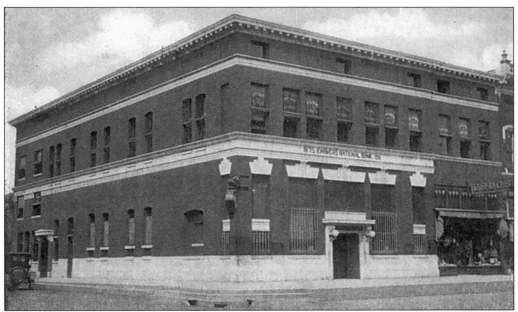

The Farmers National Bank was established in 1875. This, the bank's second building, was built in 1911 and stands at the corner of Court and Capitol Streets. The bank discontinued business in 1932 during the Great Depression. This card was printed in 1924 and on the reverse side Pekin is described as, "a city of 14,000 people, surrounded by rich agricultural country; it has thirty miles of paved streets—." The building was later used by the Pekin National Bank. (See page 40.)

AN AUTUMN DIVIDEND

The wheat, oats and hay harvest is over, and some has been marketed and brought a good price. The corn harvest is at hand and prospects indicate the largest crop that we have ever had. Now is the time that you will be looking for a safe and substantial bank to deposit the proceeds from the sale of these crops and other valuable farm products.

By depositing your funds in this bank you will have as security $225,000.00 Capital, Surplus and Undivided Profits; $400,00.00 in Government Bonds; over $445,000.00 in City, Township and County Bonds, and the benefit of thirty-five years of banking experience. Your money will not only be safe and payable on demand, but will earn you 3% interest if left for 6 months or longer.

The Farmers National Bank
PEKIN, ILLINOIS

ESTABLISHED 1875

DEPOSITORY OF THE UNITED STATES GOVERNMENT

F. E. RUPERT, J. M. JAMES, A. A. SIPFLE,
PRESIDENT VICE-PRESIDENT CASHIER

DEPOSITS OVER $1,085,000.00

This card was published in 1906 and boasts of the bank's three percent interest rate on funds left on deposit for six months or longer. The picture is brightly colored in orange and yellow tones. My Grandfather Nieukirk received this card, I suppose, either because he was a depositor or they wanted him to become one.

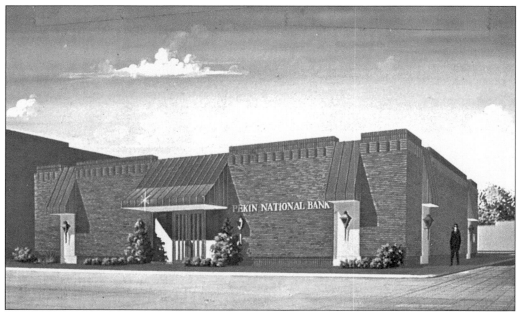

The Pekin National Bank was established May 8, 1965, and began operations in the old Farmers National Bank building at the northeast corner of Court and Capitol Streets. (See page 39.) The facility pictured here was built in the early 1970s at 329 Court Street across Capitol Street to the west from the original location.

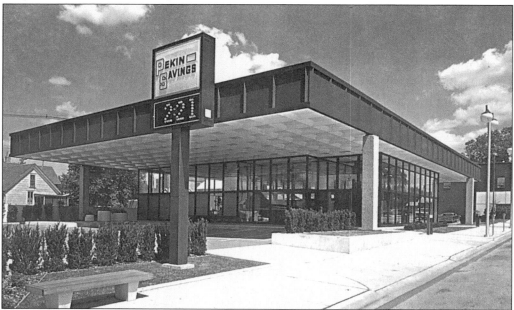

This facility of Pekin Savings Bank was erected in 1968 at 601 Court Street. The financial institution was organized in 1882 under the name Pekin Loan and Homestead Association with business being conducted from the home of C.A. Kuhl. The association grew and over the years, and moved to increasingly large quarters including 216 Court Street and 406 Court Street before settling in its present location. (Courtesy of Jim Deverman.)

The German American National Bank began business in 1887. The one-room operation soon required more space and this building was constructed at 416–418 Court Street. The new facility opened to the public November 2, 1915. Newspaper accounts told that the beautiful interior was of marble, fine walnut, and bronze. Name and ownership have evolved into the present-day financial institution at Ann Eliza and North Sixth Street known as Commerce Bank.

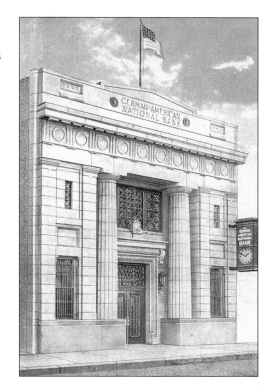

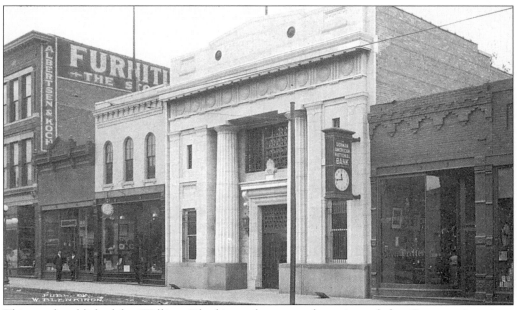

This card published by William Blenkiron shows another view of the German American National Bank. Other businesses pictured in the 400 Block, Court Street are the Albertsen & Koch Furniture Store (see the following page), Henry Birkenbusch Jewelry Store at 420, and the Pekin Freie Presse at 414.

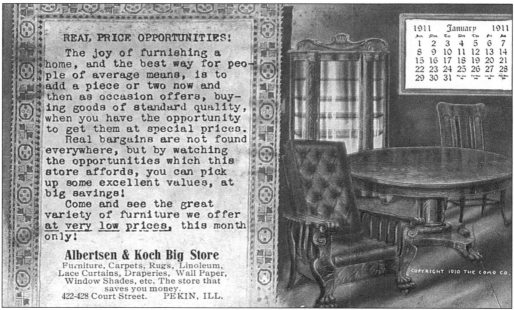

Albertsen & Koch Store was at 422–428 Court Street. The 1911 Pekin City Directory lists it not only as a furniture store, as these advertising cards show, but additionally as an undertaking business. In that era it was a common practice for furniture stores to also offer that service. The business was owned and operated by Albert H. Albertsen and Henry L. Koch.

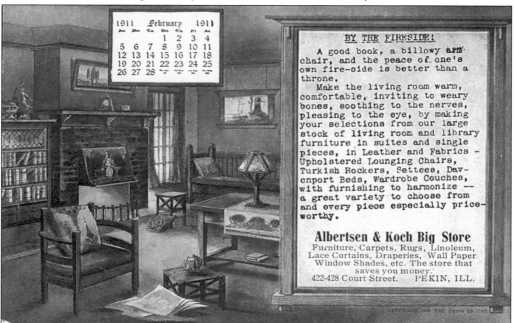

Mr. Koch sold his interest to Albertsen c.1920 and Albertsen later sold his business to the Cohen Furniture Co., which operated a store in Pekin for many years. At Koch's death in 1935, he was the last of Pekin's Civil War veterans. I have the first six months of these calendar cards in my collection; I'm not certain if similar cards were issued for the rest of the year.

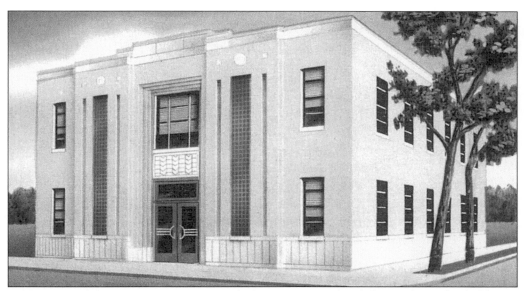

Farmers Auto Insurance Association Board of Directors circulated this card to policyholders as an invitation to an open house for this, their new office building, at the corner of South Capitol and St. Mary Streets in February 1939. The company was organized by the Tazewell County Farm Bureau in Pekin in 1921 with business limited to auto insurance. In 1948 two more stories were added to the building as shown below.

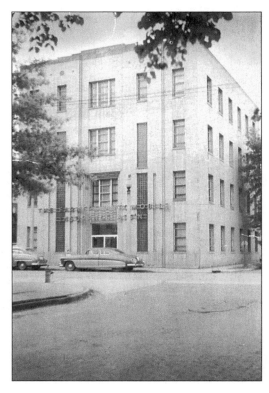

The four-story building was used by the company until 1966 when a new facility was constructed on a 30-acre tract of land at 2505 Court Street. The new building has been enlarged several times to accommodate the growing business. The company now operates under the name Pekin Insurance, which with its affiliates offers a full line of insurance. The Capitol Street building pictured here is now owned by the Herget National Bank and has had several tenants, but at present is unoccupied.

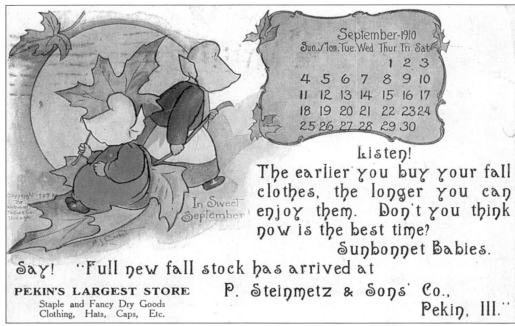

P. Steinmetz & Sons' Co. was incorporated in 1889 with son George A. as manager and treasurer. Peter Steinmetz founded the dry goods business a few years earlier. This advertising card was mailed to my Grandma Nieukirk September 6, 1910, and tells of their "new fall dress goods, silks, ladies suits, coats, and skirts." The building stands at 347 Court Street and was later used by McLellans and presently houses a furniture store. (See page 67 for the Steinmetz Memorial Chapel.)

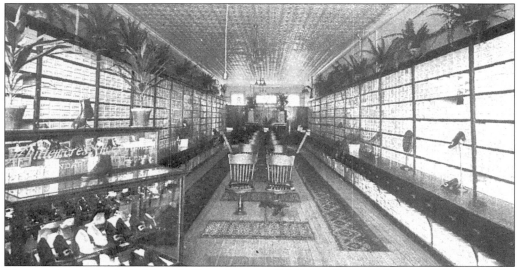

The interior of the C.A. Harnish Shoe Store at 436 Court Street is shown on this card. The advertising on the back of the card boasts, "the home of good footwear, where repairing is a specialty." The ad also indicates this is a new location. Pekin City Directories show the earlier location was at 345 Court Street. The business is listed as early as 1905 and last appeared in the 1921 directory. This card is postmarked 1912 and shows they carried a very large inventory.

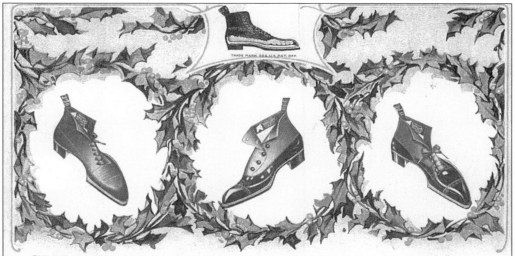

Fred W. Stoltz (1877–1967), a lifelong Pekin resident, owned and operated the Stoltz Shoe Store at 418 Court Street. The undivided-back-style card indicates it would have been printed not later than 1907. It is a colorful card with green and red holly wreaths and a yellow border. The shoe styles were high fashion for that time, but it makes my feet hurt just to look at those pointed toes.

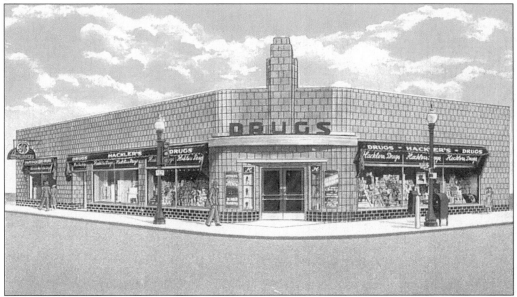

Hackler Brothers Drug Store opened for business February 28, 1923. John B., George R., and Louis H. Hackler were partners in the enterprise and continued the operation until 1960. The building, pictured here, was built in 1937 at 401–403 Court Street. Later, Thrifty Rexall Drugs occupied the building, which is presently used for various municipal offices. (Courtesy of Dean Bacon.)

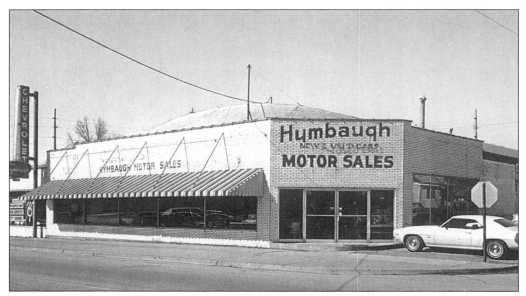

Jack Hymbaugh established Hymbaugh Motor Sales in 1946 at 900 South Second Street. The building shown here was built in 1949 at 501 South Second Street. Hymbaugh was an authorized dealer for Willeys and later Chevrolet autos and several lines of trailers. After his death in 1973, the building was used by other auto dealerships. The structure burned in 1985 and the lot was vacant for some time. Presently a mini-storage facility is at the location. (Courtesy of Jim Deverman.)

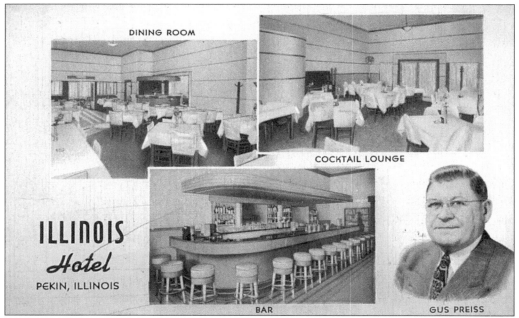

The Illinois Hotel was at 201 St. Mary Street. It is listed in Pekin City Directories as early as 1903 with John Hartman as proprietor. August Preiss is listed as owner, proprietor, and resident in 1926. Preiss died in 1944. Other names associated with the hotel before it was dropped from directory listings in 1964 include William Rodgers and Harold Nelson.

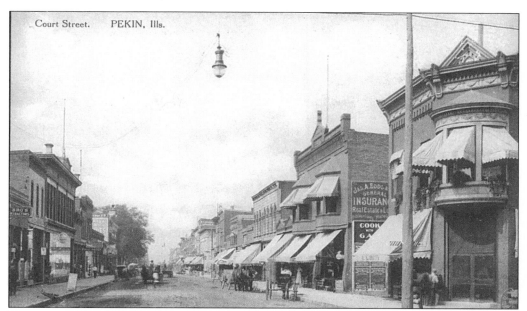

Here is another of William Blenkiron's cards. It shows the 400 Block of Court Street leading west toward the river. Notice the horse-drawn vehicles and the overhead light fixture in the middle of the street. The building at far right has for many years housed The Arlington, a bar and restaurant. The Court Theater was one of the earliest tenants (perhaps the first) to occupy the building.

These business houses in the 400 Block, Court Street include Farmers National Bank, C. Kraeger's Drug Store, Pekin Hardware, J.W. Harmel Book Store, and the Steinmetz Building. The monument at lower right reads, "1849–1904, Threshold of Tazewell House, corner of Court and Front Streets. Hereon trod the great Abraham Lincoln, Steven A. Douglas, John Logan, Robert Ingersoll, David Davis, Edward D. Baker, and others." The remnant of the early hotel was moved inside and mounted on a courtroom wall when the 1916 courthouse was built.

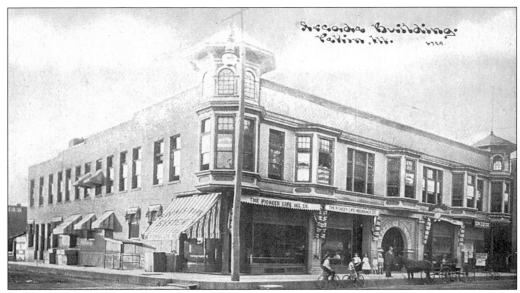

The Arcade Building, corner of Elizabeth and Capitol Streets, was completed in 1904 with original intentions, never realized, that it would house a theater. This card shows Pekin-based Pioneer Life Insurance Company occupying the street level. Other cards in my collection show tenants to be Frey's Arcade 5 and 10¢ Store and Palace of Sweets. The message on another card from my collection posted in 1907 calls it, "one of Pekin's finest new buildings." It is presently occupied by Tazewell County offices.

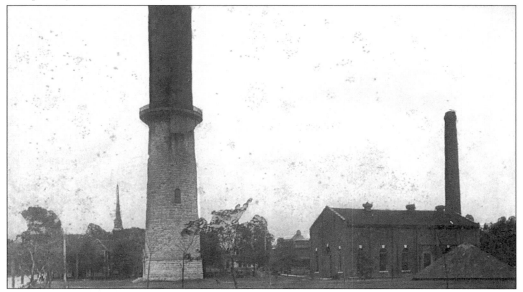

The focal point of this card is the circular stone base supporting a 180,000-capacity steel water tank. The water tower, built in 1886, was for many years a familiar city landmark at the corner of Capitol and Broadway Streets. It was torn down in 1940. A brick water fountain now stands on this corner with the following inscription: "Dedicated to the citizens of Pekin, Illinois, in celebration of a century of service (1886–1986) by Illinois-American Water Company, Pekin District."

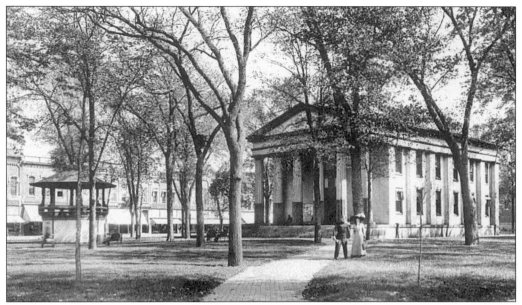

The county seat was returned to Pekin from Tremont in 1850 and this Grecian-style courthouse was built in anticipation of that move. It was razed to make way for the present Tazewell County Courthouse, which was erected on the same site bound by Court, Fourth, Capitol, and Elizabeth Streets. (See page four.) The band stand and a few Court Street business houses are visible at far left.

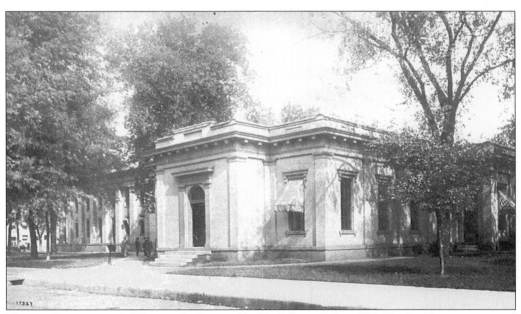

This card is captioned, "County & Circuit Clerk's Offices, Pekin, Ill." The building was erected c.1899 on Courthouse Square near the old jail. This structure and the earlier courthouse, which is partially visible at the left, were both demolished to make way for the courthouse dedicated in 1916.

The Tazewell County Jail, pictured here, was built on Courthouse Square in 1891–1892. It was a two-story red brick building, which also provided living quarters for the county sheriff and his family. It was in use until the new jail was completed c.1965. The card is dated 1914 and the message is in German.

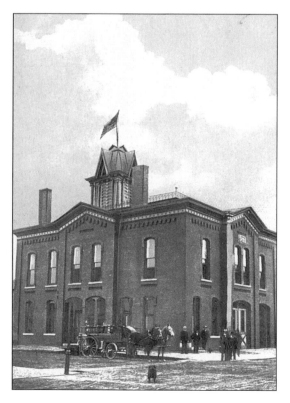

This city government building, known as city hall, was erected in 1884 on the corner of North Fourth and Margaret Streets. The building was used until the new facility, which was built around it, was dedicated June 22, 1952. The buildings were so close together that some office files were passed from open window to open window before the obsolete structure was razed.

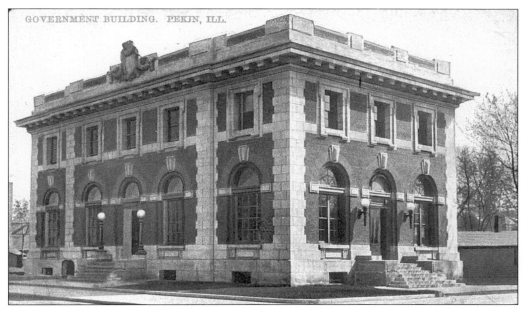

The caption refers to this picture as a "Governmental Building." That is correct, but most will recognize it as the post office. The building was erected in 1905; the exterior is described as Renaissance Revival architectural style. It stands at the corner of Elizabeth and South Capitol Streets and was used as the post office until a new facility was completed in 1967. It has had various uses since, including a restaurant, but currently is used for Tazewell County offices.

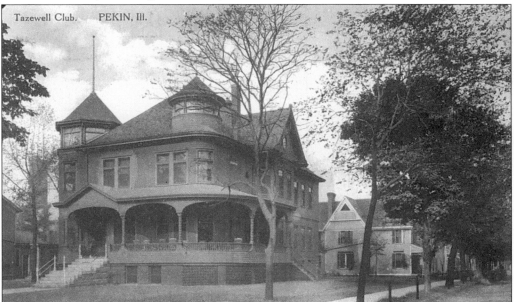

The Tazewell Club was dedicated February 12, 1896, as a place to "promote the business interest of the city of Pekin and for the social enjoyment of its members," with facilities where "the professional man, the business man, and the clerk may congregate during leisure time to enjoy a few hours in wholesome recreation." It stood at the corner of South Fourth and St. Mary Streets. The club operated until May 1960, and the building was demolished that summer.

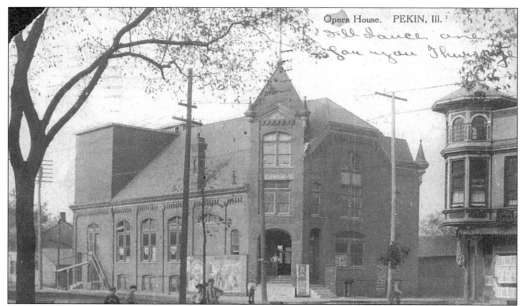

The Turner Opera House, southwest corner of Capitol and Elizabeth Streets, was built in 1890 according to the 1893 Pekin City Directory, compiled by Finney & Jones and printed by Tazewell County Tribune of Pekin. The directory lists the theater's seating capacity at 700 and names C. Duisdieker as manager. The theater was used for various types of entertainment as well as civic events such as high school graduations. (Courtesy of Dean Bacon.)

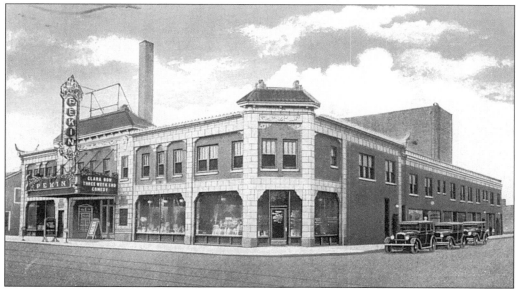

The Pekin Theater was built on the same site as the opera house and opened November 27, 1928. The building was distinguished by its Chinese decor with elaborate ornamentation carrying the oriental theme throughout. One of the decorative features was a floating ceiling giving the illusion of glowing stars. It closed as a movie theater in 1975. The structure was placed on the National Registry of Historic Sites in 1982; nevertheless, it was demolished in early 1987.

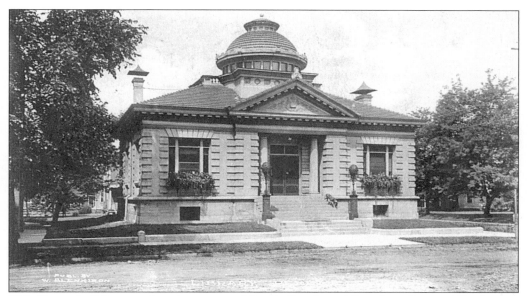

This library building stood at the corner of South Fourth and Broadway Streets. The lot was donated by George Herget; Andrew Carnegie donated $25,000 for construction costs in 1902. This card, posted in 1908, has a straightforward message, which reads in part, "Now that we have become acquainted through exchanging cards, don't you think it would be very nice to exchange photos? I have some, but please send yours first." It is signed Lillian and mailed to a gentleman. Did he or didn't he?

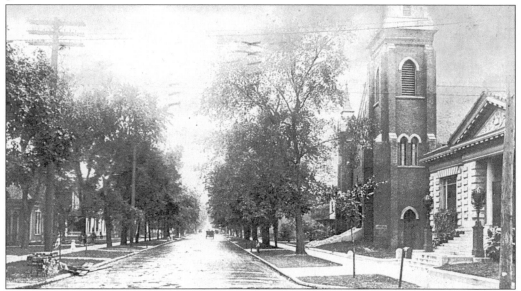

The library, also seen in this South Fourth Street scene, was demolished in 1974 to make way for the new public library and Dirksen Congressional Leadership Research Center. Also visible is the First Presbyterian Church built in 1873. It was organized as the American Reformed Church. It too was razed to make way for the new library complex. Construction of a new church facility was begun in 1964 in Sunset Hills. The congregation is presently known as First United Presbyterian Church.

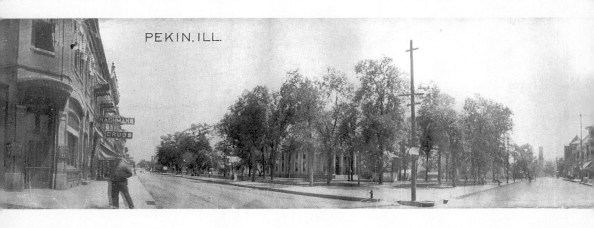

This card shows a panoramic view of the intersection of Capitol and Court Streets. The card is of standard height, but is 21 inches long! It was published for Hull Drug Store, Clinton, Illinois. A caption on the back reads, "This card can be rolled instead of folded for mailing." I've been told such pictures were made in early days with cameras that advanced the film around a drum as the image was recorded. To the extreme left is a bit of Court Street looking east, and on the south side of the street the old courthouse is visible. This helps date the card as the courthouse was razed in 1914. The wide street left of center is South Capitol; the water tower and the Arcade Building may be seen in the distance. The center building is Schipper and Block

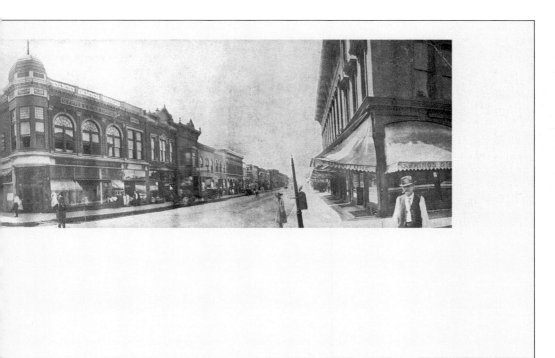

Company, a dry goods store. This was the company's second building on this site. The first was destroyed by fire in 1898; the replacement building, shown here, was also destroyed by fire. Pekinite John Kriegsman recalls watching from his sixth-grade classroom window in Lincoln School as this building burned. The date was February 1922. A third store building was erected at this location and was open for business until the early 1960s. The street to the right is Court Street looking west toward the river. Heckman and Spangler Furniture Store is visible at extreme right. This building had a ballroom on the second floor.

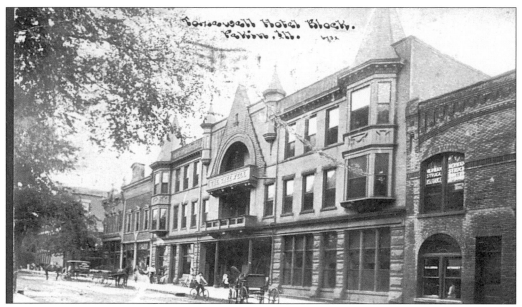

The Tazewell Hotel was built c.1900 at 350 Elizabeth Street. It was razed in April 1962, and the site is now a parking lot. Earlier the Woodard Hotel, destroyed by fire in 1899, stood at this location. The structure at extreme right was built in 1899 by a group of Pekin attorneys. They named the building, which is still used by attorneys, the Marshall Building in honor of Supreme Court Justice John Marshall. This card is postmarked 1911 with a flag cancellation, and the message is in German.

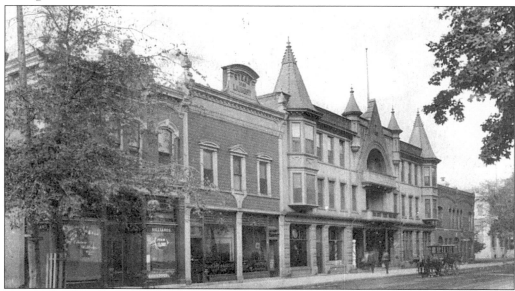

Another view of the Tazewell Hotel block shows two buildings to the left (east) of the hotel more prominently. According to a 1911 Pekin City Directory, the building adjacent to the hotel is the Pekin Steam Laundry and Pantatorium (I don't know either!), William J. Dittmer, proprietor. The 1893 directory refers to it as the Pekin Steam Laundry and Bath Rooms, John Nolte, proprietor. At extreme left is the Saratoga Cigar Store and Pool Hall.

Five

WHILE STROLLING THROUGH THE PARK

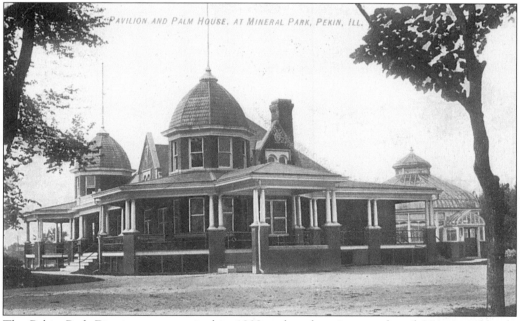

The Pekin Park District was organized in 1902 and at that time purchased 80 acres of land, which became Mineral Springs Park. The pavilion and palm house shown on this 1908 card were built c.1906; the palm house was razed in 1970. It had been used for horticultural displays and, according to early records, seedlings were propagated there for use in landscaping the park. The park lagoon, which is directly behind the pavilion but out of sight on this photograph, was used as a watering hole for cattle at the time of the 1902 purchase. The spring-fed body of water was excavated to greater depth and transformed into a recreational lake. The current seven-member Park Board, an elected body, now manages 1,940 acres of park land, of which 203 acres comprise the present Mineral Springs Park.

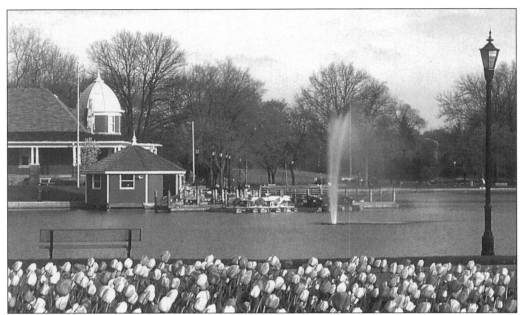

Two fountains were installed in 1989 in the lagoon. This view of the pavilion and the lake shows one of the two. At one time the pavilion provided housing for the park manager and his family. The building also housed a concession stand, and rowboats could be rented there by patrons for use on the lagoon. This is a pretty, colorful card with blue water and tulips in shades of yellow and red. (Courtesy of Jim Deverman.)

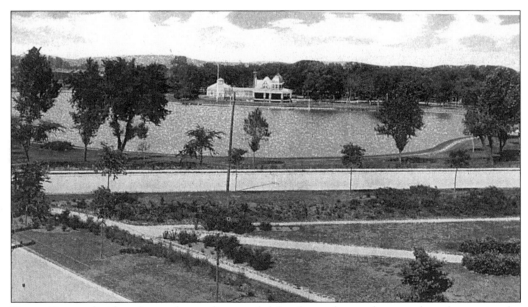

Court Street divides the park pavilion and lake from the sunken garden shown in the foreground of this card. The sunken garden, part of the original acreage acquired in 1902, was developed in 1924.

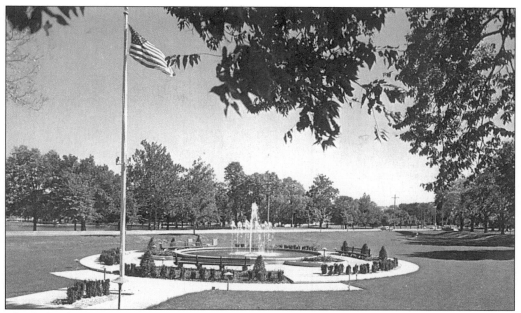

The lighted fountain shown on this 1975 card was installed in the sunken garden in 1970. A unique sundial, advertised as, "the world's greatest," is also located in this area of the park. (Courtesy of Jim Deverman.)

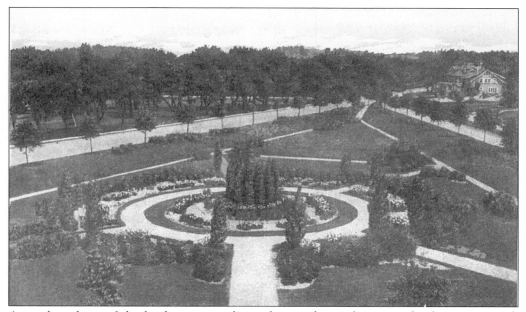

An earlier photo of the landscaping in the sunken garden is shown on this linen type card. Court Street runs along the left side, and a small section of Park Avenue may be seen at upper right. (Courtesy of Dean Bacon.)

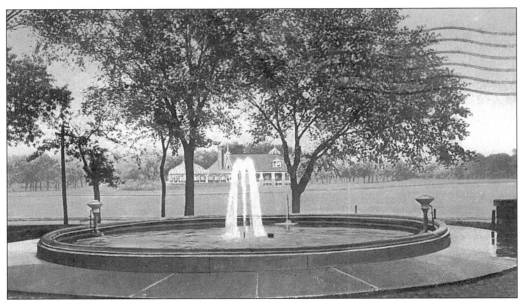

This fountain was located on the west side of the lagoon near the parking lot of the present Miller Senior Citizen Center. It is agreed that the fountain was removed many years ago, but no one seems to remember exactly when.

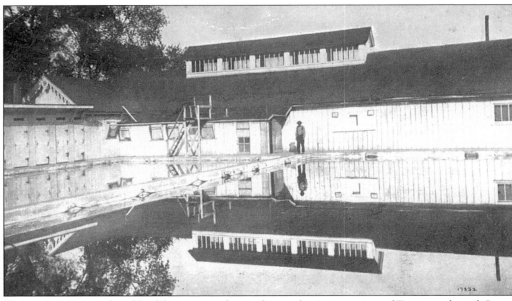

This swimming pool and bathhouse were located near the intersection of Fourteenth and Court Streets in the vicinity of the present Miller Senior Citizen Center. The two large basins were alternately filled with sulfur water, warmed by the sun, used, and drained. The dressing rooms or cabanas may be seen at extreme left. At one time there were several sulfur wells in use in the park but only one is used today.

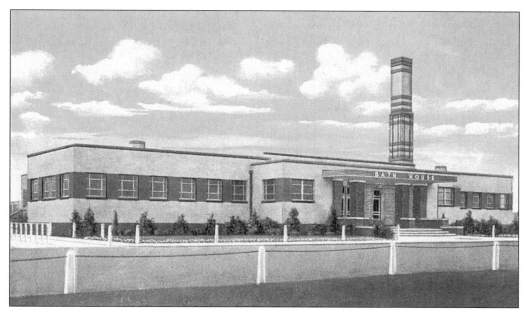

The bathhouse at Mineral Springs Pool was built in 1936. George Poppo Wearda was the architect and Ernest L. Rohrer was the builder, according to the metal plaque attached to the building near the front (south) entrance. The structure is presently used for Park Board offices. (Courtesy of Dean Bacon.)

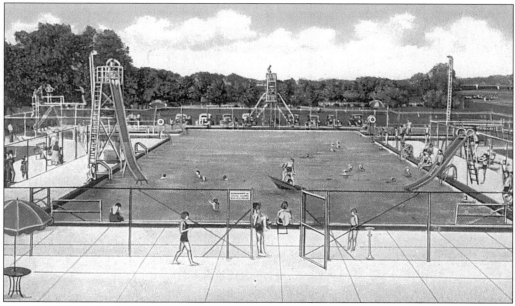

This 500,000-plus-gallon pool was opened in the summer of 1937. It was one of the first in the state to have a water filtration system. Featured at the north end of the pool, where water was 12 feet deep, was a high diving board. The first daring jump off this board, usually at about age 13, was a rite of passage of sorts. The pool closed c.1991 and presently a miniature golf course is being developed at the site. (Courtesy of Dean Bacon.)

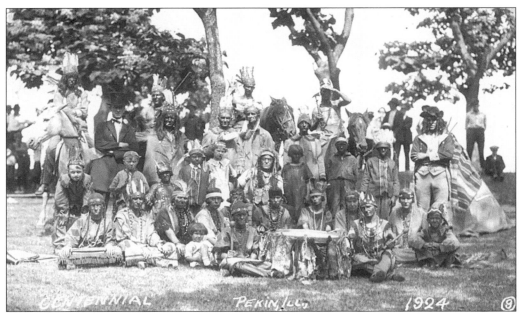

These two cards show scenes from the Indian village and trading post set up in the park as a part of Pekin's centennial celebration in 1924. Chief White Eagle, a Shoshone, and his official family established the setting and performed native dances and pantomimes throughout the festivities. The cards are numbered nine and ten indicating they are part of a series. I have only two and do not know how many more were printed.

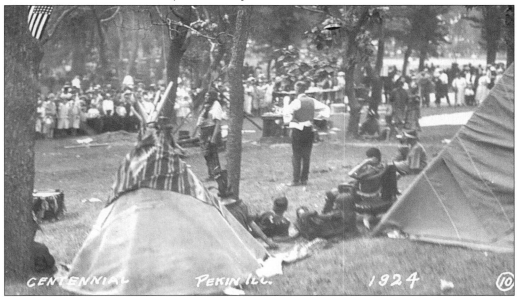

The celebration marking the 100th anniversary of Pekin's founding was attended by an estimated 110,000 during its three-day run culminating on the Fourth of July, 1924. Featured activities included free beef barbecue (the first time for many locals to taste the Southern treat), concerts by the municipal band, a band from Canton, a parade, the masked ball, ballgames, fiddlers' and pie-eating contests, fireworks, and an elaborately staged pageant.

Six

THIS OLE HOUSE

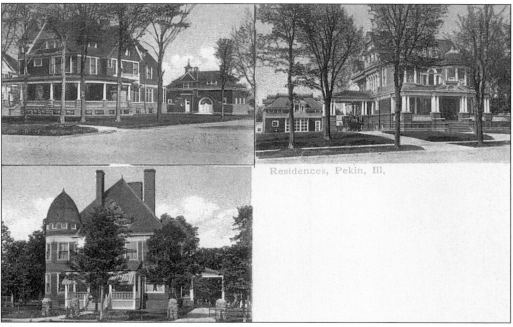

Residences, Pekin, Ill.

The three houses shown here were among Pekin's finest in 1908 when this card was posted. The upper left shows the Henry G. Herget home, which was built c. 1896 at 615 Park Avenue. It was demolished in 1997. The structure in the background of this photograph was originally the carriage house. It is identified as 729 South Seventh Street and is presently owned and occupied by Ernst and Alice Svndsen. The home at upper right was built in 1903 by William P. Herget and stands at 725 Park Avenue. Present owners are Benny and Earline Kasinger. The house at lower left was built 1886–1889 at 905 South Fifth Street for Everett W. Wilson, who at one time was Pekin's mayor and president of the German American Bank. The building was purchased in 1942 by the Abts family and adapted for use as the Abts Mortuary, which still operates at the location today.

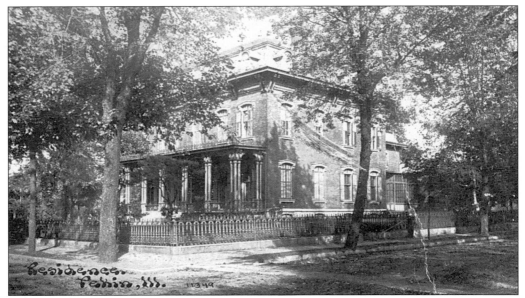

This splendid home was built for well-known Pekin businessman Teis Smith in the late 1860s. Smith's heirs owned the property until 1955, when it was sold to Preston Funeral Home. The house still stands at 500 North Fourth Street, and is still utilized as a funeral home. The structure was originally three floors; however, the top floor was removed many years ago, and other extensive remodeling has been done. Although very well maintained, the present exterior bears little resemblance to this 1912 photograph.

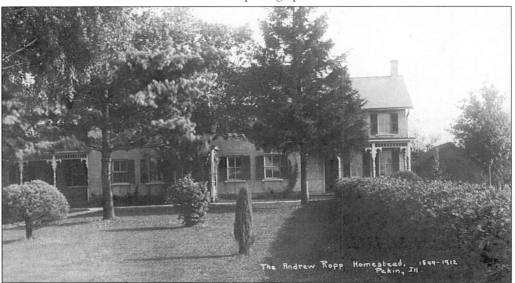

This house stands at 17957 Illinois Route 9, Pekin, Illinois, in Section 18 of Elm Grove Township. Andrew Ropp built the house in 1836 and ownership has remained in the family ever since. Current owner, Warren Miller, is a lineal descendant of Ropp. The structure was built of bricks and in 1890 the exterior was coated with a one-half-inch layer of cement and scored to give the appearance of cement blocks. This 1912 card was sent as an invitation to the eighth annual Ropp reunion.

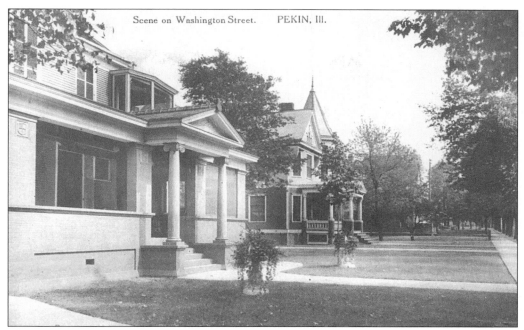

Scene on Washington Street. PEKIN, Ill.

This card shows the north side (odd numbers) of the 700 Block, Washington Street. The house at far left (west) has been owned by Dr. John Sombeck since 1996. One of the Steinmetz family members was an early, if not the first, owner. The center house at 709 Washington Street was built for a man named Nolte c. 1896. It was purchased in December 1990 by Mr. and Mrs. John Neuman, the present owners. Both of these homes have been well maintained.

This stately home, standing at 801 Washington Street, was built in 1892 for Henry Ehrlicher. In 1941 the house was purchased by Arthur Ehrlicher, a nephew of the original owner. Virginia Ehrlicher, Arthur's widow, owns and occupies the house at present.

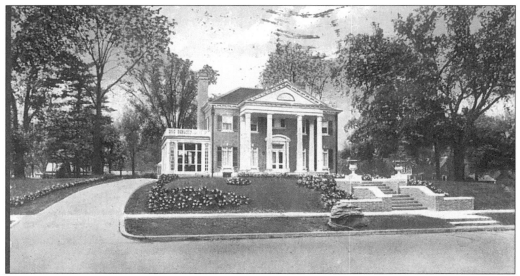

The Carl Herget residence pictured on this 1916 card was built *c.* 1912. It was an elegant home with marble fireplaces and a third-floor ballroom. In later years it was used as corporate headquarters for Vogel's Inc. and its subsidiary, Bird Provision Co. The affiliated company was so named because the German word "vogel" translates to "bird" in English. It stands at 400 Washington Street and more recently has been used as a bed and breakfast.

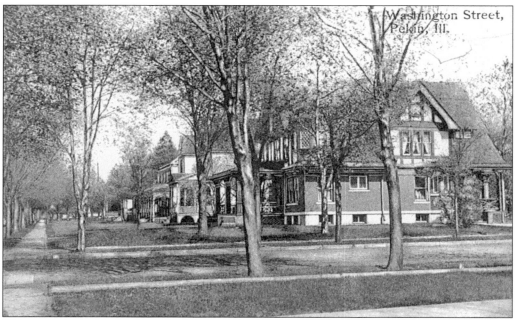

This card shows the south side (even numbers) of the 700 Block, Washington Street. The house at far right is identified as 700 Washington Street and currently is owned by Robert Oliverius. Other names earlier associated with this property include D.C. Smith Jr., Dr. Wm. Niergarth, Ludwig Schurman, and Virgil W. Vogel.

Seven

MEMORIES

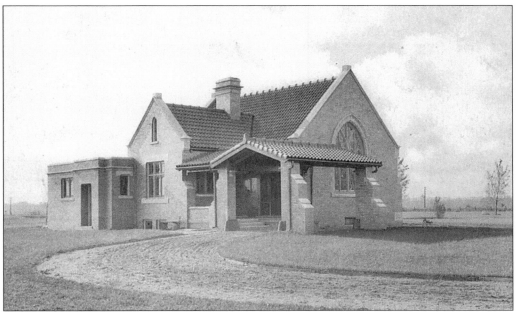

The Steinmetz Memorial Chapel stood in the northeast corner of Block Eleven of Lakeside Cemetery. The building was beautiful with stained-glass windows and fine wood furnishings, but was seldom, if ever, used for the purpose intended. Over the years it was allowed to deteriorate into a deplorable state and was ultimately demolished c. 1958. A large marble monument depicting The Lord's Supper was erected in its place. The original cornerstone was incorporated into the new monument. It reads, "In memory of Peter & Fredericka Steinmetz. This chapel was builded in the year 1909 by George A. Steinmetz, Henry Steinmetz, Lena L. Smith, Anna S. Kaylor, Louise Albertsen, and Emma Schenck." Two large concrete pillars topped with metal spheres still mark the entranceway from North Eighth Street which originally lead to the chapel. The spheres now have a rich green patina.

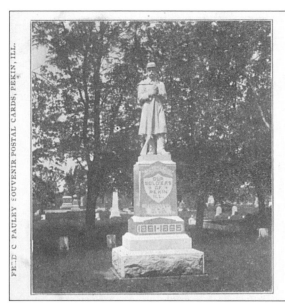

The Soldiers' Monument in Lakeside Cemetery was dedicated May 30, 1905. The inscription reads, "In memory of our soldiers of Pekin, Illinois. Erected by W.R.C. #236." The Woman's Relief Corps #236 met the second and fourth Friday afternoons each month at the G.A.R. Hall, 616 Court Street. The memorial statue honoring local Civil War soldiers still stands in good repair. This is one of a series of souvenir cards distributed by Ferd C. Pauley.

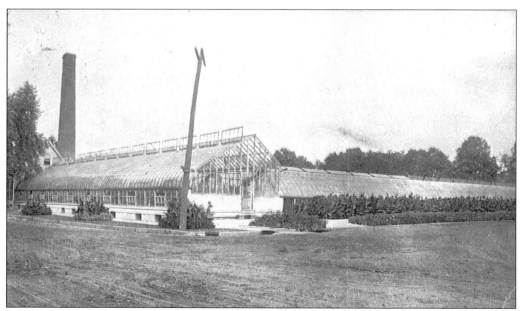

The Kuhl Greenhouses, George A. Kuhl, proprietor, were also known as the Prairie Lawn Greenhouses. The facility had 55,000 square feet under glass. The business at 716 South Fifth Street supplied customers from a wide area. This card bears a 1910 Ind. & Peoria R.P.O. (Railway Post Office) postmark.

These two humorously romantic greetings were postmarked in 1913. Cards of this type were available in many cities and were very popular with deltiologists because of the audacious style and because the automobile was still new enough to be a fascination. A similar card from Tremont is included on page 116.

This popular style greeting card shows five familiar Pekin scenes: the post office, a river scene, a Court Street scene, the courthouse, and a Fourth Street scene. It was printed in Germany for distribution by Pekin druggist Carl Kraeger. The card bears a 1909 Pekin postmark, and the message reads in part, "Oh, let me get away from this place."

This similar card was also printed in Germany and was distributed by J.A. Weber of Pekin. The card was mailed from Pekin in 1908. Colorful cards of this type were available across the country in cities large and small and became appealingly popular with collectors.

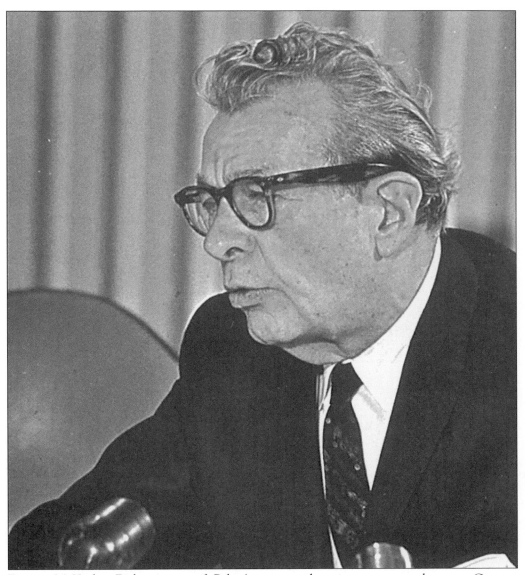

Everett McKinley Dirksen, one of Pekin's renowned native sons, was born to German immigrants January 4, 1896. His father was a decorator of carriages and buggies at Pekin Wagon Works. The elder Dirksen named his sons for prominent Republicans. Everett's middle name was for Governor McKinley of Ohio, who later became president; his twin brother was named Thomas Reed for the then Speaker of the House; his older brother Ben was named for Benjamin Harrison, who was president at Ben's birth. The boys were labeled for life as Republicans! Dirksen won the 1932 congressional primary against incumbent William Hull of Peoria, and was ultimately elected in spite of a Roosevelt landslide. He was elected to the senate in 1950 and became minority leader in 1959. Dirksen was known for his eloquent style of oratory and his extensive vocabulary. His political antagonists jested that he likely didn't know the meaning of all those big words he wove into his speeches, but of course, he did. He was a master of sesquipedalianism! At his death in 1969, he was considered one of Washington's most recognizable and colorful figures. (Courtesy of Jim Deverman.)

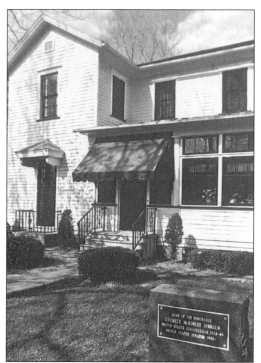

This house was the Dirksen family home in Pekin. It belonged to Mrs. Dirksen's mother, Lillian Carver, and stands at 335 Buena Vista Street. The marker on the front lawn reads, "Home of the Honorable Everett McKinley Dirksen, United States Representative 1933–1949, United States Senator 1951–." (Courtesy of Jim Deverman.)

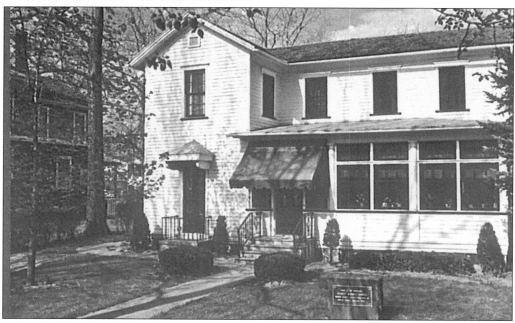

George R. Babcock is listed as the owner of this house in the 1861 Directory of the City of Pekin published by Omi E. Root. The property was identified as, "Buena Vista, 4th d.n. of Washington," or the fourth door north of Washington on Buena Vista. Another early owner was William Gaither, a member of the Whig Party, who served as Tazewell County sheriff from 1859 to 1862. Mark Werner is the present owner. (Courtesy of Jim Deverman.)

Year after year Senator Dirksen introduced bills that would officially make the marigold the national flower. The legislation never passed, but his relentless effort earned him the nickname, Mr. Marigold, and resulted in horticulturist, David Burpee, naming the Dirksen Marigold in his honor. Pekin's Marigold Festival is held each autumn in memory of the senator. The event is highlighted by thousands of his favorite flower growing throughout the city. (Courtesy of Jim Deverman.)

This display was for the 1975 opening of the Everett McKinley Dirksen Congressional Leadership Research Center, which is a non-partisan, nonprofit organization that seeks to improve civic engagement by promoting a better understanding of Congress and its leaders through archival research and educational programs. Dirksen's congressional achievements, for example, his role in passage of the Civil Rights Bill of 1964, are chronicled here. Luella Carver Dirksen has said of her husband in reference to that bill, "Not only was Everett the pivotal figure in the passage of the bill, but he practically wrote it." (Courtesy of Jim Deverman.)

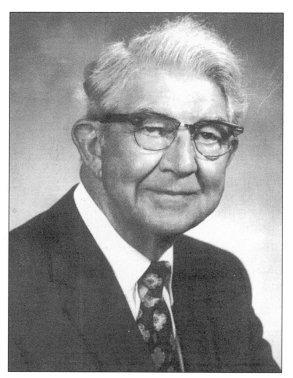

Postcards bearing this portrait of William R. Zimmerman (1905–1988) were mailed as a part of his November 2, 1976, election campaign. He was the successful Republican candidate for circuit clerk of Tazewell County, an office he held from 1952 to 1979. He served seven consecutive terms beginning in 1961 as president of the Illinois Association of Circuit Clerks.

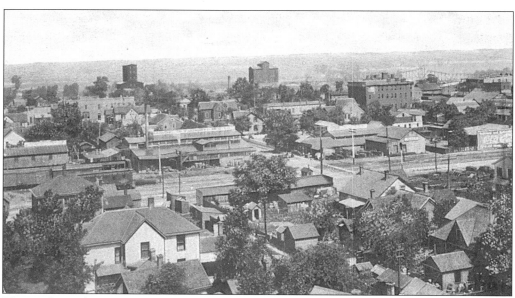

This card is aptly captioned, "Bird's eye view of Pekin." The Illinois River and bridge are visible in the background to the west. The railroad tracks and cars are shown with the industrial buildings logically situated between the river and the railroad. The large building just left of center is the Duisdieker Foundry. A residential area is included in the foreground. The card was published by J.A. Weber of Pekin.

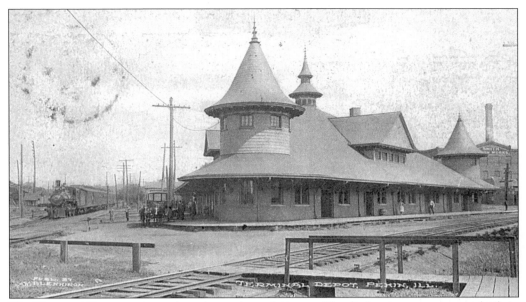

The Terminal Depot is pictured on the cards on this page. The distinctive structure was built in 1899 and was used as a railway passenger station for many years. The well-known landmark was demolished in the mid-1930s. Visible at far right is the sign identifying the Smith Wagon Works building.

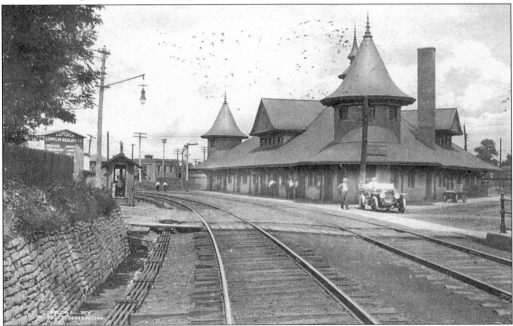

In addition to the old depot this view also shows the Conklin-Reuling Lumber Company building at left. The stable of the American Brewing Company is visible in the center background. The crossing in the foreground is Ann Eliza Street. This card is postmarked 1915 and the message admonished the addressee, "Hope you are not sitting up too late nights and losing sleep!"

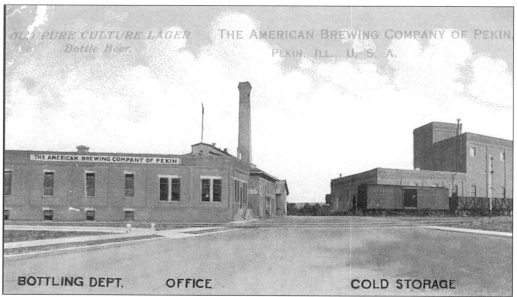

OLD PURE CULTURE LAGER
Bottle Beer.

THE AMERICAN BREWING COMPANY OF PEKIN.
PEKIN, ILL., U. S. A.

THE AMERICAN BREWING COMPANY OF PEKIN

BOTTLING DEPT. OFFICE COLD STORAGE

The American Brewing Co. of Pekin was established in 1900 when the old Winkel Brewery was purchased by Chicago interests. The 1916 Pekin City Directory gives 109 Caroline Street as the office address and lists C.G. Herget as president. The firm had been under Herget ownership for several years, when it ceased operations about 1916. The directory ad tells they were "Brewers and Bottlers of Old Pure Culture Lager Bottled Beer" under the name "Pekin Prima."

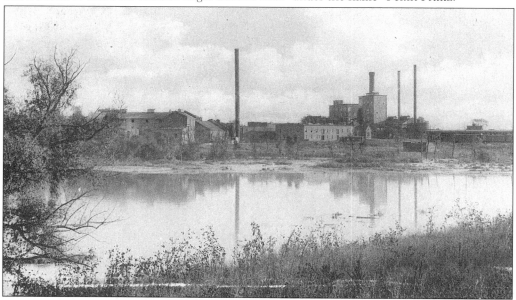

The Globe Distilling Co., another of Pekin's early enterprises founded by the Herget family, was built in 1892. It operated under the Globe name until being sold in 1898. The facility was at the south end of Second Street along the Jacksonville and Southeastern Railroad just beyond city limits. Company offices were at 363 Court Street with phone #68. Standard Brands operated from this same building company.

76

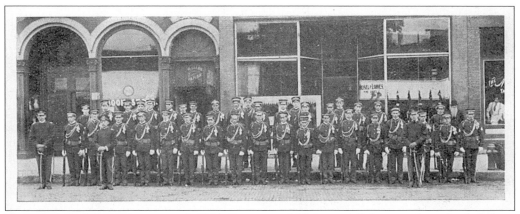

This 1906 card shows Company A, Fifth Regiment, I.N.G., in full dress uniform. Included are O.W. Friederich, captain; H.F. Bross, first lieutenant; and J.P. St. Cerny, second lieutenant. The building in the 300 Block, Court Street housed Wm. Blenkiron's bookstore; Heisel and Lohnes Shoe Store, owned and operated by partners Wm. J. Lohnes and John G. Heisel; and upstairs, the Wm. Laass tailor shop.

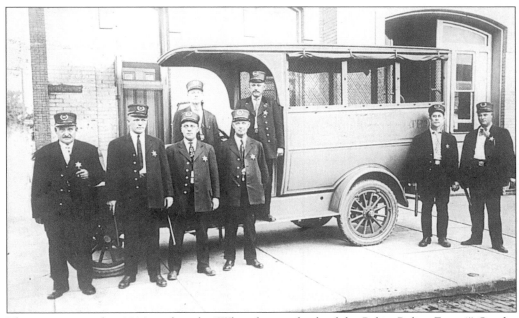

The message on this 1916 card reads, "What do you think of the Pekin Police Force?" On the side of the vehicle are the words, "Pekin Ambulance Patrol." The sign at far left on the building identifies the location as Fourth Street. It is likely the old city hall, which stood at the corner of Fourth and Margaret Streets (shown on page 50). The structure was razed in the fall of 1951 as a new city building was erected on the same site.

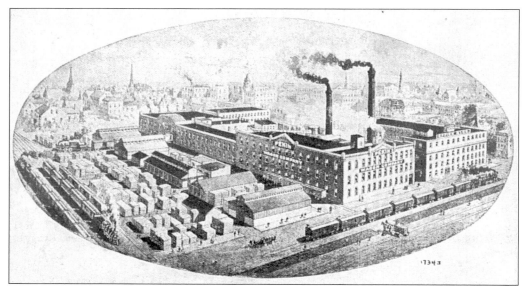

The Smith Wagon Company, one of Pekin's earliest successful manufacturing businesses, was established in 1849. The factory was surrounded by Third, Capitol, Margaret, and Ann Eliza Streets. This card identifies the plant as the Pekin Wagon Works. Early advertisements refer to it as the, "Home of Pekin and New Ebbert Wagons." The facility was later used by several related enterprises. It was partially destroyed by fire in the 1950s and was completely demolished several years ago.

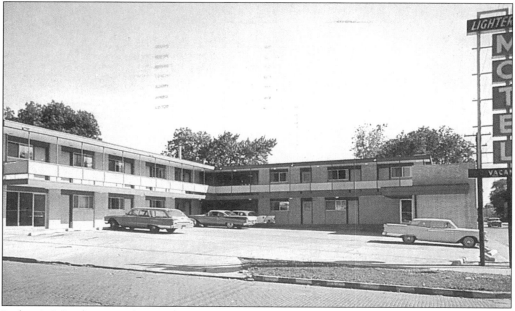

Lighter's Motel was at the southeast corner of Fifth and State Streets. The back of this card describes it as "ultra modern, new in 1960, and free TV." The message reads in part, "This is where my husband and I spent our wedding night. It's just wonderful being married." The card was posted September 23, 1963. The building at present is used for one room efficiency apartments. P.S. Wouldn't it be great if Judy and Dick still think married life is wonderful!

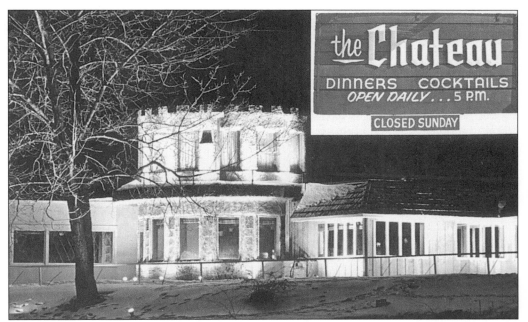

This building was erected in 1948 by the 40 & 8, a branch of The American Legion. The structure designed by Pekin architect Frank Starcevich Sr. was a favorite meeting place for area veterans for many years. The unique turret is an interesting architectural feature. The building in later years, as shown here, has housed a restaurant known as The Chateau. Brothers Gene and Bernie Kouri, the present owners, bought the restaurant in 1977 from Vernon Rohrs.

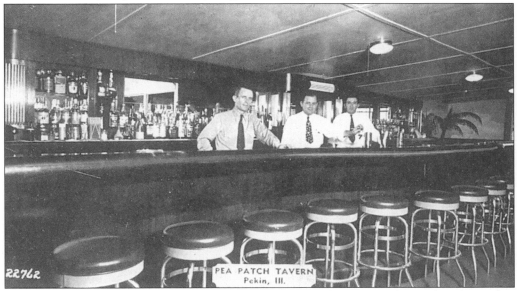

The Pea Patch was a popular tavern and meeting place in the 1940s. This card was posted in 1941 and advertises a 5-acre parking lot, dancing, good music, and fine food, all in a friendly atmosphere. The night spot was located on the east edge of town on Tremont Road (State Route nine). George Bouris is a name many will recall as associated with this establishment. The gentlemen pictured are unidentified.

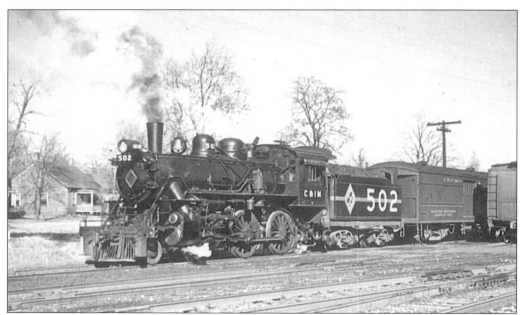

Shown here is Engine #502 of the Chicago & Illinois Midland Railroad as it paused in Pekin. The card, which was never mailed, has a caption on the back showing the date of the photograph to be November 19, 1951.

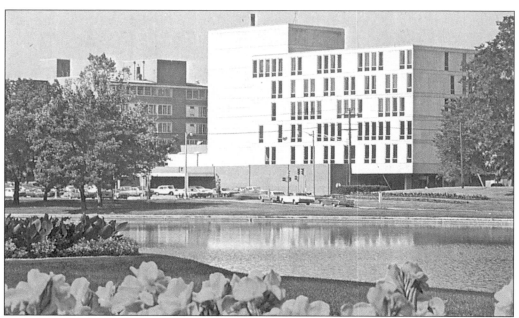

The Pekin Memorial Hospital, as it is now known, was chartered with the State of Illinois in 1913; however, it was 1918 when the first building was opened with a 20-bed capacity. Building additions were opened in 1932 (cornerstone reads 1931), 1954, 1967, 1977, and 1986. The present facility has 132 beds for patients admitted. The hospital complex is bound by Court, Thirteenth, and Fourteenth Streets, and Park Avenue. (Courtesy of Jim Deverman.)

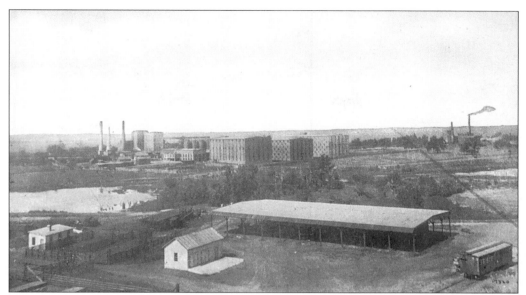

The cards on this page show the American Distilling Company facility. The first plant was erected in 1892 on the same site as an earlier distillery. The company expanded substantially in 1908. During World War I the company converted to the production of industrial alcohol used in the war effort. After the end of prohibition, whiskey production was resumed in late 1933.

According to the caption on the back of this card, the American Distilling Company, Pekin, Illinois, home of Bourbon Supreme, occupies 49 acres on the Illinois River. Bourbon Supreme, American's premium-quality, straight bourbon whiskey, and other leading American Distilling Brands, are famous for "Quality by American." The Chicago, Northwestern Railroad bridge is shown in the background.

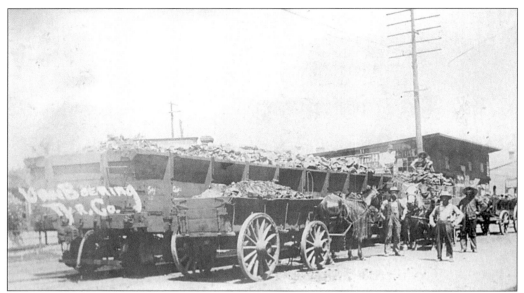

Oscar Van Boening owned and operated the Van Boening Transfer Co. out of an office at Third and Margaret Streets. In 1913 Philip J. Kriegsmann (later spelled with one n) acquired the business from Van Boening. The deal included 30 wagons and 32 horses. Kriegsmann owned grocery and meat markets in Peoria, which were traded to Van Boening as part of the deal. One of the Peoria stores was at the corner of Main and University Streets, the end of the street car line.

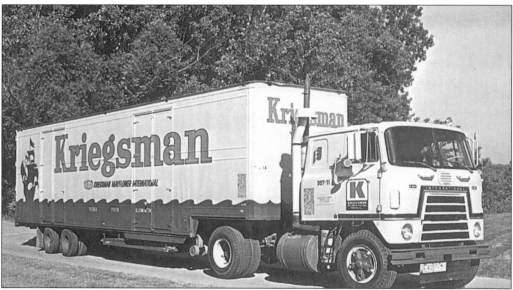

Kriegsman Transfer, under the leadership of Philip Jacob Kriegsman and family, developed into a very successful moving and storage business. One of the company's huge vans is shown here. Kriegsman, at one time before going into business for himself, worked as an organ tuner for Hinners Organ Company. (See page 37.) The carrier in early years transported organs for Hinners to 11 midwestern states, according to present-day Pekinite John Kriegsman. (Courtesy of Jim Deverman.)

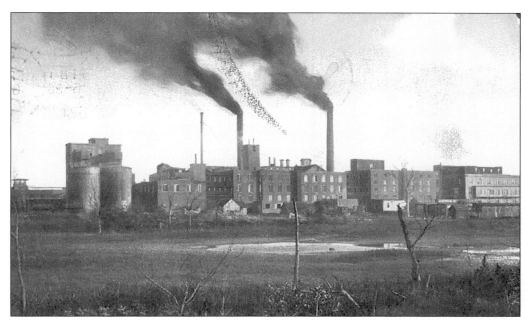

This card is postmarked 1908 and is captioned "Illinois Glucose Co. Works." The sugar refining factory was established in 1898 by Henry Herget and was called the Illinois Sugar Refining Company. Many locals referred to it as the "sugar house." It was converted to a glucose plant in 1901. Beets were used in the production process.

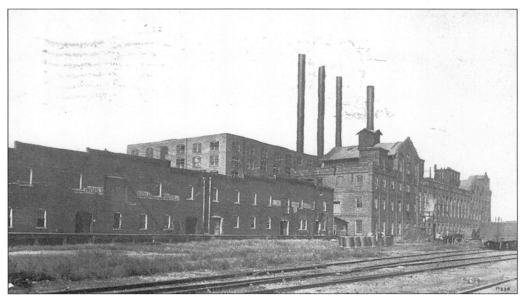

This card, captioned, "Corn Products, Refining Co.," is postmarked 1914. The company was formed in 1906 and took over the "sugar house." Corn, which could be bought for 50¢ a bushel, was now used in the manufacturing process, as the name implies. The sign on the building at left reads, "Illinois Sugar Refining Co. Warehouse," a reference to the company's earlier name.

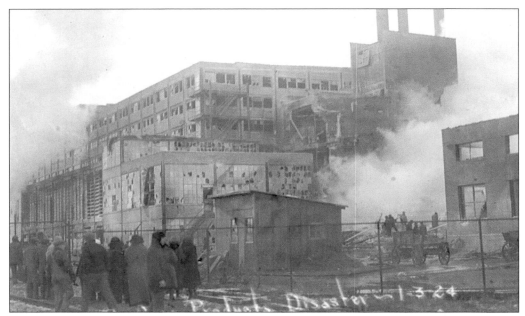

The Corn Products plant was struck by a devastating explosion and resulting fire early on the morning of January 3, 1924. Forty-two workmen were killed, some of whom were never positively identified. An additional 120 were injured, some maimed for life. The facility was Pekin's principal industry, and the newspaper accounts reported the disaster was one of the worst factory catastrophes in American history.

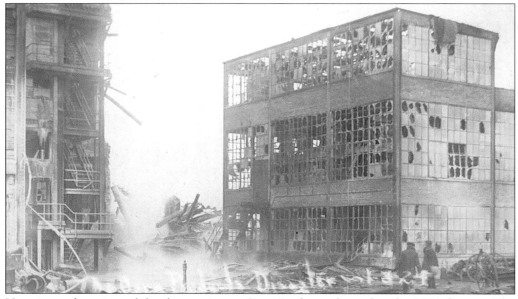

Here is another view of the devastation at Corn Products plant after the 1924 disaster. The impact on the community was tremendous; mass funerals were held on successive days at the high school. The state fire marshal and U.S. Department of Agriculture investigators concluded the fire was caused by an overheated bearing that ignited starch dust. The factory was closed only briefly and reopened as temporary buildings were constructed.

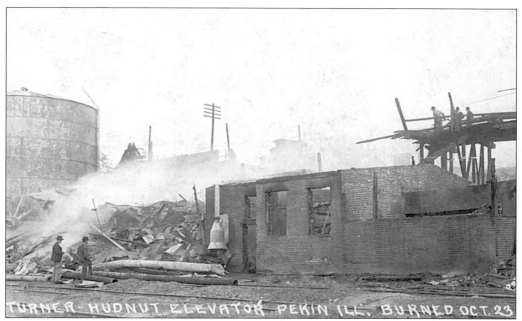

The *Pekin Times* of October 24, 1910, reported a $75,000 conflagration caused by a miscreant firebug. The Turner-Hudnut Elevator was a heap of ashes and rubble on the morning of the 23rd. It had been one of the largest grain elevators in central Illinois. The spectacular fire could be seen for many miles because of the height of the grain bins. A failed attempt to torch the nearby Smith-Hippen Company was also made.

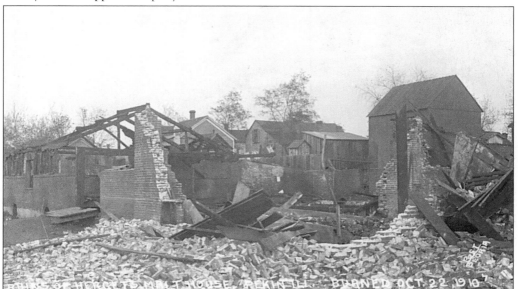

The Herget Malt House, located on Front Street, was destroyed by fire of incendiary origin the same evening as the above elevator. The malt house, owned by Philip Herget, had been in operation for several years. Although at the time of the fire, it was only being used for storage. Several railcars, including two owned by the Big Four, were also destroyed in the disastrous blaze.

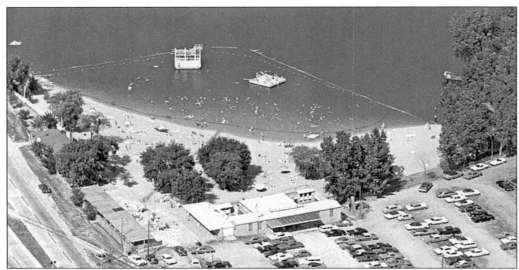

Charles and Mary Maquet bought Twin Lakes Bathing Beach in 1952. It remained in the Maquet family until 1986, when the property was sold to Dick Thompson of Tremont. He ran the business only a short time, and the site has been unused and for sale for several years. Originally under Maquet's ownership the popular spot was open from 10 a.m. to 10 p.m. daily. Entry fees for a full day were 25¢ for kids and 50¢ for adults. No amount of spraying could rid the place of bloodthirsty mosquitoes, so evening hours were later curtailed.

The Pekin section of the book is completed with this typical souvenir card. The inscription is in gold and the seashells are embossed in gold, so it is a very attractive card. Similar cards were sold in many cities far, far away from any seashell source. However, it's interesting to note Pekin in early years had a business, which used the then plentiful clam shells from the Illinois River to make buttons for clothing.

86

Eight
COME ON'A MY HOUSE

This card *c.* 1910 shows Tremont houses, three of which are still used as single family dwellings today. The upper left is identified as the F.J. Davis house. It was built by Jacob Velde *c.* 1902–1903, and Davis acquired it in 1909. The property was later owned by Carl Schimmelpfennig. It was demolished in 1984 and the site is at present a parking lot for the Tremont Baptist Church. The upper right shows the home of Mrs. Henry (Margaret) Hazelman. It stands at 319 North Sampson Street and was later owned by the R.A. Cullinan and John Webb families. Lower left image was in 1910 the residence of Dr. J.M. Cody. It is also shown on page 91. The lower right is identified as the D.A. Stormer home. Local contractor Edward Cooney built this and other similar houses in the area from cement blocks which he made in Tremont. This house on South James Street was for many years the home of the William Bolliger family and later the Weston New family.

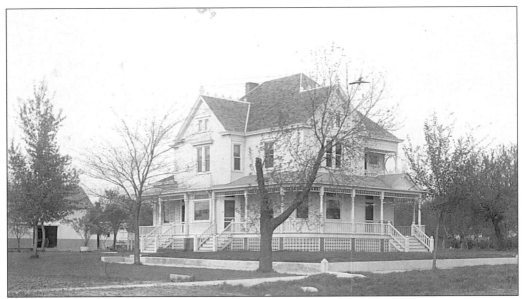

This large house is identified on the card as the residence of Reverend Ballenger. He did live there with his wife, Annie Robison, who owned and occupied it before her marriage to Ballenger. Subsequent owners were Alma Gilmore and currently James and Susan Sommer. The house stands at 201 East Tazewell Street facing the north edge of the village park. (C.U. Williams #7376.)

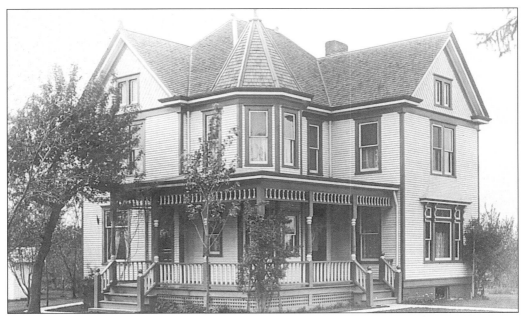

Richard and Adelaide Papenhausen Becker purchased this house at 317 North Sampson Street in 1906 and lived there until sometime in 1924. It is not known when, or by whom, the dwelling was built. Subsequent owners include Mollie Helleman, Jim and Mary Ann Benson, and the present owner, Todd Bong. (C.U. Williams # 7372.)

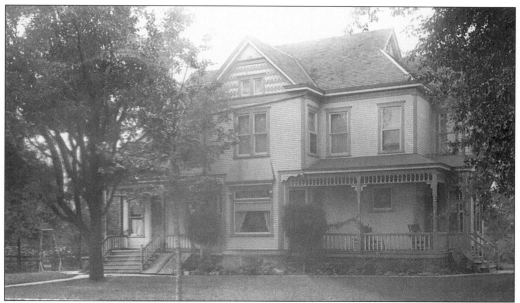

This house at 301 South Warren Street was the residence of the J.W. Barkdoll family. Barkdoll came to Tremont in 1893 and the house was built soon thereafter. The card bears a 1907 postmark. The house was destroyed by fire January 16, 1948. Barkdoll's daughter, Lula, and her husband, A.C. Schneider, then owned the house and they rebuilt at once on the same site. (C.U. Williams #1884.)

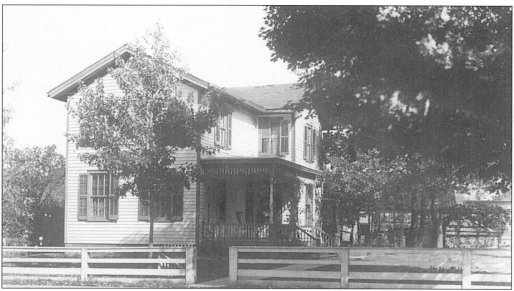

This c. 1910 card shows the M.E. Parsonage. One of the early owners of the lot was Flavel Bascom, a licensed preacher of the Congregational Church. The building was owned by the Congregational Church and subsequently by the Methodist Episcopal Church. It was used as their parsonage until 1924, after which the Frank Blue family lived there for several years. It stood in the 100 Block, South Locust Street, and was demolished in the mid-1980s. (C.U. Williams #9615.)

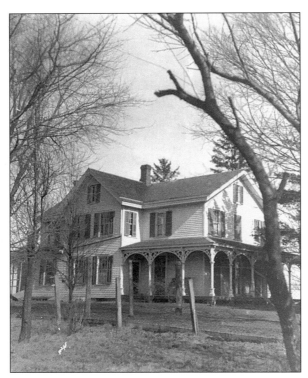

Pictured here is the farm home of Jacob Winzeler (1854–1932) in Sec. 29 of Tremont Township. The photograph dates from *c.* 1915. Family members relate that Winzeler engaged a consultant from Marshall Field and Company in Chicago to come to Tremont to oversee the interior decorating and appointments for the house. One can easily surmise this to be an unusual occurrence for that era in Tremont. The home has been extensively remodeled and has been owned for many years by the Daniel Steiner Sr. family.

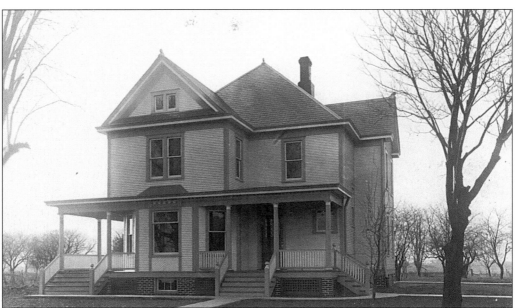

This photograph is identified as the Chris Getz family residence. The house was built for Getz *c.* 1900 in Section 17 of Tremont Township. Later owners include Mabelle Bennett, John Gerstner, Ben Baer, and Marvin Baer. State Route 121 divided the adjoining farmland into two tracts which were connected by a passageway constructed under the highway. (C.U. Williams #22508.)

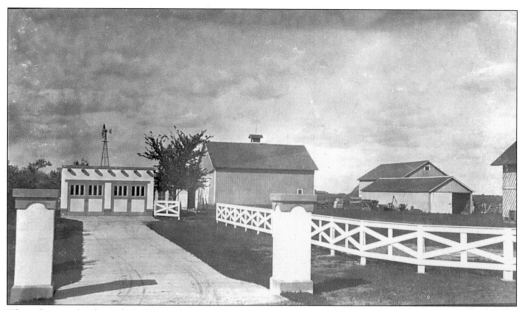

This shows the board fence and pillared entrance to the Winzeler farmstead pictured on the opposite page. The pillars and fence are no longer in place as the narrow entranceway hampered the movement of modern farm machinery. The card is dated September 1915.

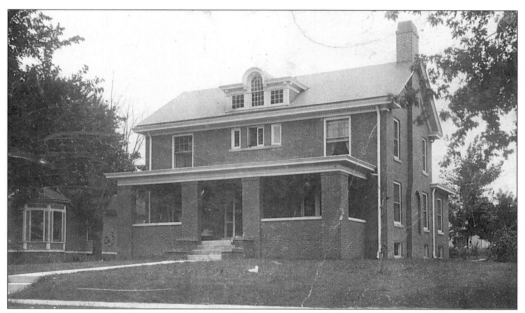

This house is identified as the residence of Dr. J.M. Cody. Belle Cody acquired the property in 1906 and the house was likely built about that time. John Papenhause acquired the property c. 1917–1918. Subsequent owners include Ed and Midge Koch and Elton and Helen Rapp. The red brick house stands at 104 East Pearl Street.

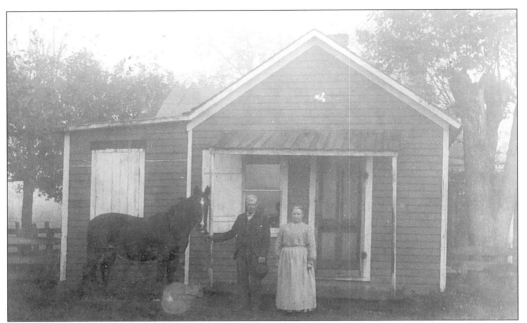

Pictured here are Stephen and Rosetta Tunis Dillon in front of their home in the settlement of Dillon southwest of Tremont. Stephen has patrilineal kinship with the earliest settlers in the Village of Dillon and Tazewell County. Rosetta was my Grandad Tunis's sister. She at one time operated a small telephone switchboard in their Dillon home, presumably, one of the first to service Tremont. The Dillons were married in 1875 in the parlors of the Woodard Hotel in Pekin. (See page 56.)

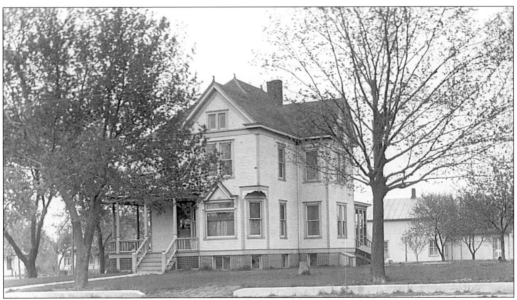

A.G. Norman and family lived in this house when the photograph was taken c. 1910. Mr. Norman at one time operated a shoe store on South Sampson Street. The house at 101 East Tazewell Street remains a private residence today. (C.U. Williams #7375.)

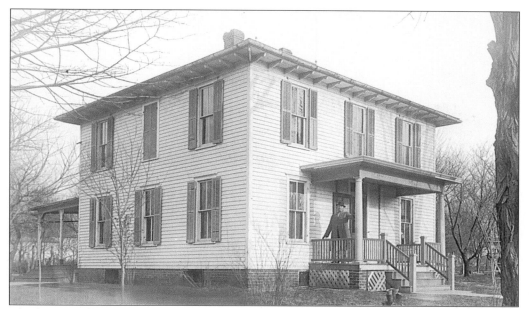

This house, still standing at 400 South Locust, was first occupied by the Robert Kennedy family. It was purchased in 1938 by the Apostolic Christian Church and used for worship services until 1948. It has been a private residence since that time. (C.U. Williams #27162.)

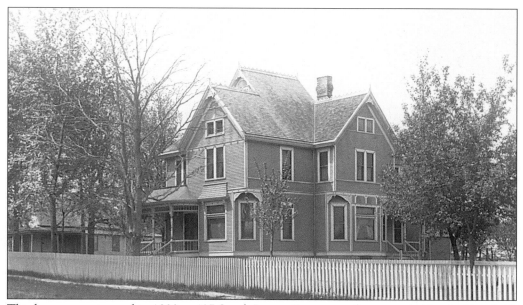

This house, constructed in 1893 at 427 South Locust Street, was first occupied by the Enoch G. Morse family. Morse's granddaughter killed herself in an upstairs bedroom in 1907. Rumors persist that the house is inhabited by her ghostly spirit. The house's grandeur has been maintained by subsequent owners. (C.U. Williams #7385.)

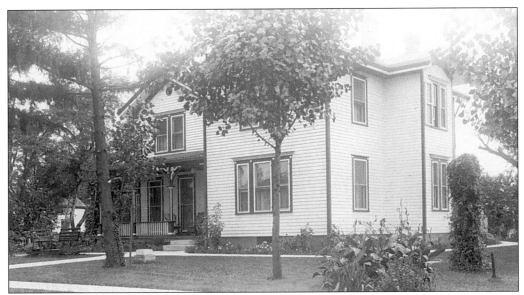

This card *c.* 1910 shows the residence of Mrs. Alford Leonard. Walter Dale Shepherdson and family moved to this house at 205 South Locust Street in 1915. Ownership has remained with that family, the present owner being V. Jean Shepherdson. (C.U. Williams #1883.)

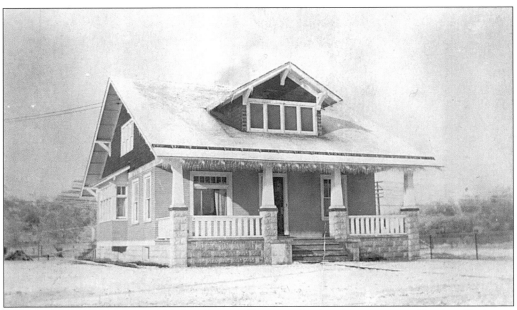

This home was built in 1917 for George Gerstner by local contractor Charles Hodgson. Gerstner later sold the house to Frank Hoffman. The dwelling stands at 429 South Sampson Street and is presently owned and occupied by Mildred Bliss.

Nine
DOWNTOWN–TREMONT

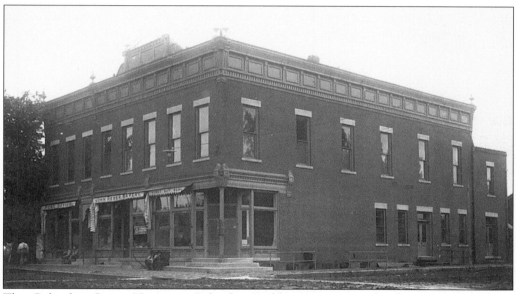

The Columbia Opera House or Columbia Building, as it was also known, was built in 1898–1899 by local contractor Fred Trout. The two-story red brick structure had a gala grand opening October 27, 1899. The *Peoria Star* reported, "A large number of Pekinites have made arrangements to go to Tremont to attend the opening of the Opera House there and the grand ball." It was also reported, "The Opera House is a costly one and perhaps the best in the state for a place the size of Tremont." The theater with crystal chandeliers and an ornate proscenium arch outlining the stage was on the second floor. Many local and traveling groups performed there. Signatures of some artists can still be seen on backstage walls. It is recorded that high school graduations, oratorical contests, prize fights, basketball games, wrestling matches, and other forms of entertainment were also held there, although nobody recalls ever seeing an opera! The second floor has been stripped of its grandeur and is currently in serious disrepair. Its only use is for rough storage and one small apartment. (C.U. Williams #1879.)

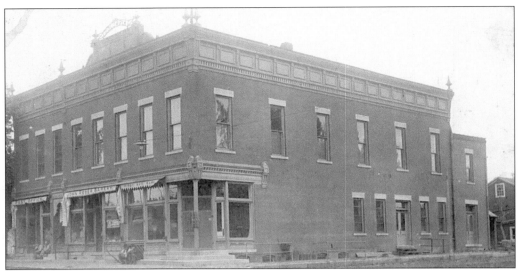

This slightly different view of the Columbia Opera House also partially shows a building at far right, which was at one time used as a livery stable. This card is posted 1913 and the message is signed, "Mr. and Mrs. John Reber." The center awning reads, "John Reber Bakery." My mother worked briefly at the bakery as a teenager and later told me bread sold at six loaves for a quarter. (C.U. Williams #1879.)

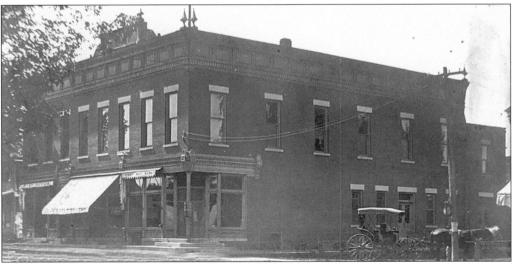

The Columbia Building stands at the corner of Sampson and Walnut Streets. Over the years its tenants included a bank, post office, bakery, meat market, laundromat, pool hall, tavern, barber shop, jewelry store, creamery, telephone office, farm supply store, dentist's office, restaurant, flower shop, and a silent movie theater. Charles Alexander told me that Roy O'Brien paid him 50¢ a night to play his trumpet during reel changes for the movies!

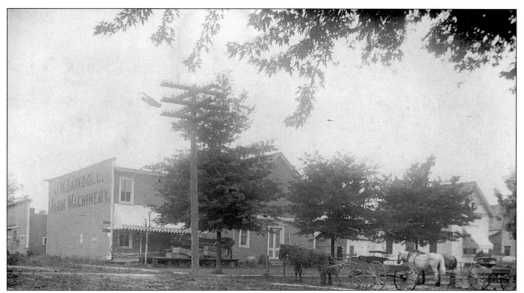

Jacob W. Barkdoll moved to Tremont from Mackinaw in 1893. He owned and operated this buggy and farm implement store and at one time also ran a creamery and a blacksmith shop. He was Tremont's mayor in 1897 and was reelected in 1902 for five years. At age 16 he joined the 38th Ohio Vol. Inf. to fight in the Civil War with his brother. Barkdoll was with General Sherman on his infamous "march to the sea."

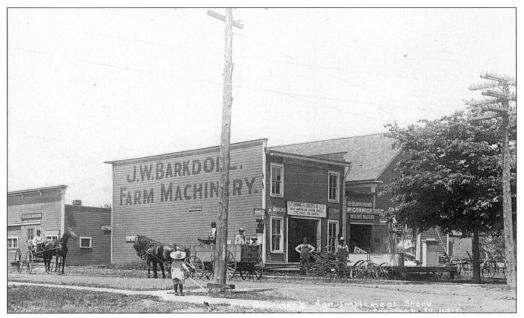

Dean A. Stormer later operated an implement business in the same set of buildings, which stood facing east in the 200 Block, South James Street. Wouldn't it be interesting to know the name of the little girl with the wagon! Both cards on this page are C.U. Williams's photos.

The Commercial Hotel at the southwest corner of James and South Streets was in 1910 "a nice place," according to the penciled message on this card. M. Shertliff was owner/manager from 1907 to 1912. Stephen Dillon, my great uncle, took over in 1912. Several others tried their luck at running this business before the building was razed in 1917.

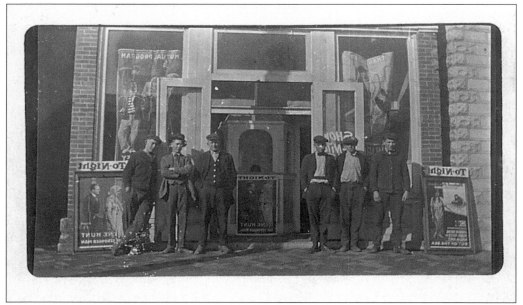

This building at 212 South Sampson Street was purchased by Gipps Brewing Co. shortly after it was built in the early 1890s. Edward Cooney bought the building in 1897 and began his saloon business. James Cooney (second from left) opened this theater *c.* 1910. The card, mistakenly printed as a reverse image, tells Universal Studios' star Irene Hunt appeared in, "The Stronger Man." Cooney later operated a confectionery and billiard parlor, and at his death in 1944 he ran a tavern at the same address.

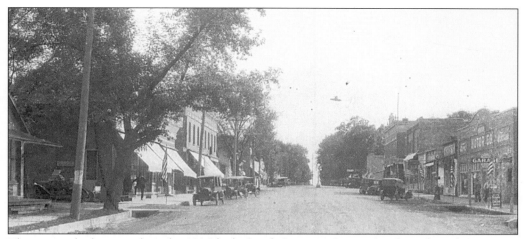

This view is looking south in the 100 Block, South Sampson Street. On the right is the Hinman Ford Garage. The sign in front advertises Red Crown Gasoline. Next door to the south is the A.G. Norman Shoe Store. Velde Hardware and Columbia Opera House are visible in the distance.

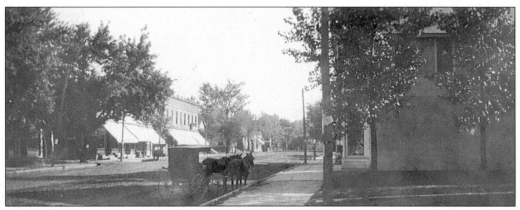

This nearly deserted street is also the 100 Block, South Sampson looking south. Sampson Street was paved in 1928 but was unpaved at the time this photograph was taken and the sidewalk was of brick. The building on the right side (west) was a general merchandise store operated by Frank McGinnis. The large building on the left (east) is the New City Hotel. The horse-drawn carriage indicates this is a very early picture.

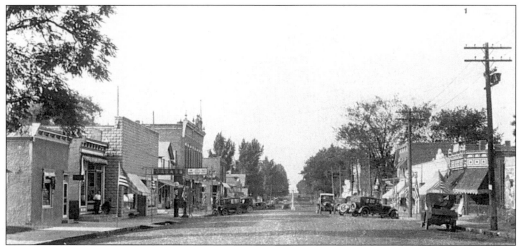

Shown here is the 200 Block, South Sampson Street, looking north. At the left is Gottlieb Hermann's building; the awning advertises boots and harness. The cement block building is the Star Garage. It was owned and operated by Walter Dale Shepherdson from 1917 to 1933. He sold and serviced Nash autos. Carl Schimmelpfennig later owned and operated the garage. The tallest building is the Columbia Opera House. Notice the light post in the center of the street.

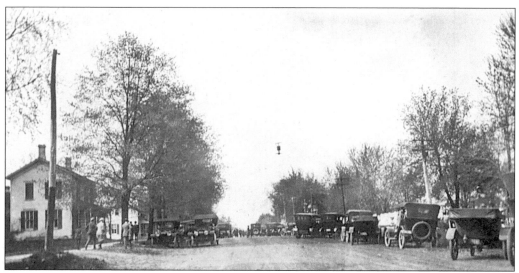

The crowd is gathering for some major event in the village park to the right of the parked cars. The unpaved street is the 200 Block, North Sampson Street. The house on the left, built c. 1876, was first owned by the Kipp family. Later it was owned by Esther Washburn and Julia Hayward. The home was demolished several years ago and the land is now owned by R.A. Cullinan and Sons, Inc.

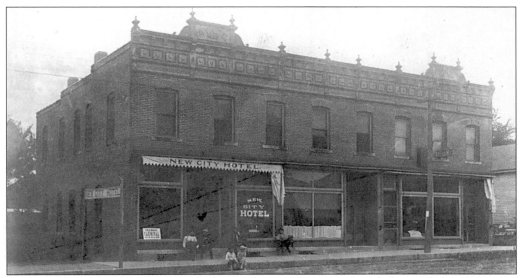

The architectural ornament to the left atop this building is inscribed, "City Hotel, 1903." To the right the inscription reads, "Tremont Bank, Est. 1879." The window poster dates the photograph as 1908. James Shepperd ran the hotel at that time. Rooms rented for $1.50 a night. Myrtle Altine (see page 120) was paid 25¢ a week for part-time kitchen work. The Tremont Bank was founded by A.G. Davis and L.M. Hobart and is a forerunner of the present bank.

This building housed several businesses after the hotel closed. Pictured in this 1913 card is Wm. C. McQueen (Tremont's mayor 1937–1957) in front of his furniture store. Subsequent tenants include Sharp Brothers, a general merchandise store, and the First National Bank, which evolved from the 1879 bank. The second floor was used at one time as a dance hall and later for apartments. The structure was razed in 1966 to make way for the new bank facility.

In 1963 Glen Windsor moved his drug store business to this newly constructed building at 216 South Sampson Street. Windsor purchased the drug store at 123 South Sampson in 1948, after the death of former owner Frank A. Blue. After Windsor's retirement in 1984, Richard Wartick bought the business, including this building. He still owns the building and now manages the business for the present owner, Pekin Memorial Hospital.

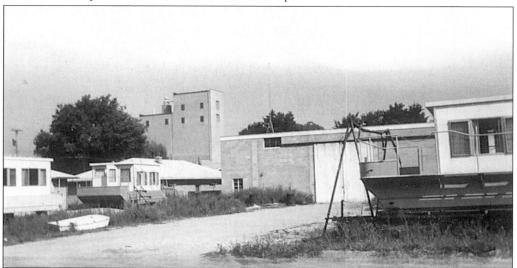

Dr. Harvey A. Evans built his new office facility in 1954 in the 300 Block, South James Street. Shortly thereafter he built and operated the Maid of the Mist Houseboat Factory pictured here. This business was directly behind (to the east) the James Street office. The boat factory discontinued operations in 1963. The building was purchased in 1966 by Tremont Township, and has been used for storage and a garage since that time.

Ten

IN A LITTLE RED SCHOOLHOUSE

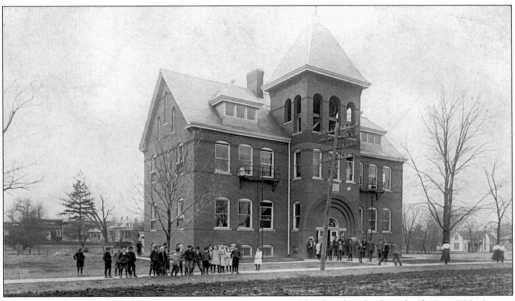

This red brick schoolhouse was used for both grade and high school when built in 1892. It was an impressive two-and-one-half-story structure with full basement and steepled bell tower. The Tremont Historical Society Museum has in its archives one of the printed programs from the January 13, 1893, dedication. Dignitaries from both Illinois Wesleyan University and Illinois State Normal University participated in the event. Additional classrooms were constructed in 1903; directors at that time were James Dean, president; Wm. F. Gerstner, secretary; and A.H. Menard. The class of 1895 was the first to graduate from the high school. The class had three members, namely, Belle McGinnis, Maude Gay Parnell, and Dr. Frank Hinman. They graduated after a three-year course of study. The curriculum included algebra, physics, Latin, and zoology. The large school bell, which hung in the bell tower, is now attractively mounted as a public display in the northwest corner of the present grade school yard.

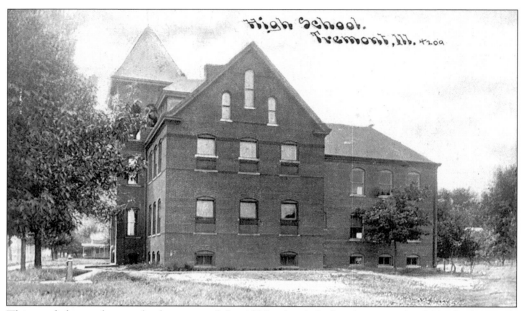

This card shows the north elevation of the 1892 school. It faced east in the 200 Block, South Harris Street. It was never used exclusively for high school, as the inscription implies. The building was torn down in 1967 to make way for the new grade school which opened that fall.

Chiseled above the two front doors are the words, "Community Building." It was indeed used for a variety of community events; however, most knew it as the school gymnasium. Built in 1933 after the old wooden gym burned, it was ostensibly demolished in 1966; although, part of the structure was incorporated into the new grade school that opened in the fall of 1967.

Pictured here is Tremont High School senior George Holliger, as he set a vaulting record (10' 3") at the Tazewell County Track Meet held in Tremont May 11, 1917. Attendance was estimated at 1,500. The Big Four could not accommodate all who wanted to board the morning train in Pekin. One of the oiled streets in the village was used as the track.

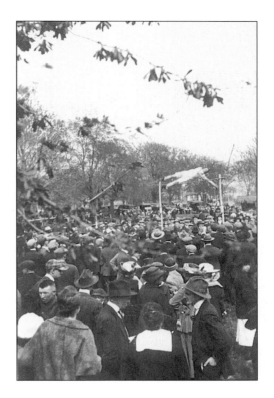

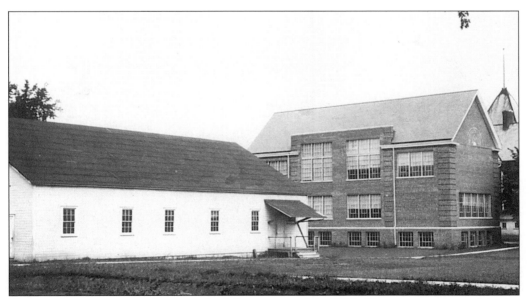

The wooden gymnasium shown at the left was erected in 1923. The structure burned in the spring of 1933. To the right is the 1926 high school addition to the 1892 structure. The gym faced west in the 200 Block, South James Street, and the brick buildings faced east on South Harris Street.

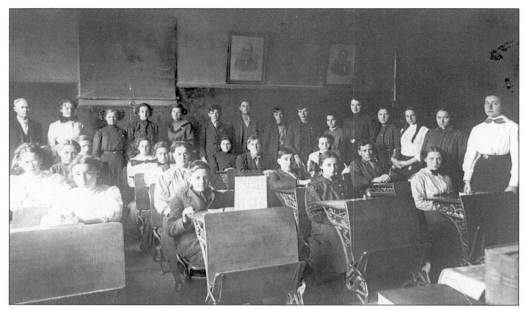

This group is the entire Tremont High School in the spring of 1911. Teachers pictured are Mr. Gibbs and Miss Nina Grotevant. All students are identified and names are on file at Tremont Historical Society Museum.

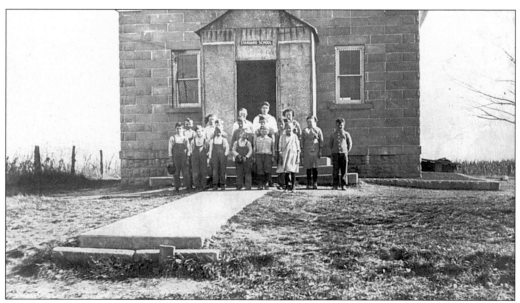

The Leslie School, District #72, was built in 1907 in Section 15 of Elm Grove Township. It was initially designated as District #5 and was named for nearby Leslie Station (railroad). The school was closed in 1949 after which the students were enrolled in school in the village. The township later used the building for storage and as a polling place. It was burned in 1967 by the Tremont Fire Department as a training exercise. The teacher in this photograph is Eunice Mundy and the only student identified is Mary Rowell, second from the right.

This card picturing the Tremont High School in the spring of 1912 was sent to my Aunt Eura by class member Ruth von Krumreig. Standing left to right are Elmer Koch, Elizabeth Koch, Principal Harvey Whetzel, Allington Jolly, teacher Miss Evans, and Ruth von Krumrieg. Seated is Elizabeth Stewart. The little boy, who died in childhood of diphtheria, is Whetzel's son.

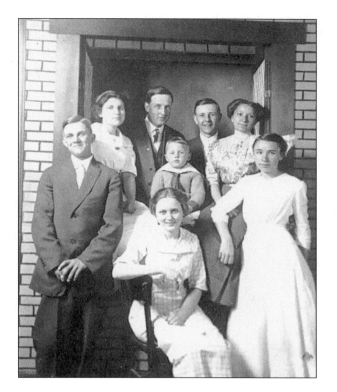

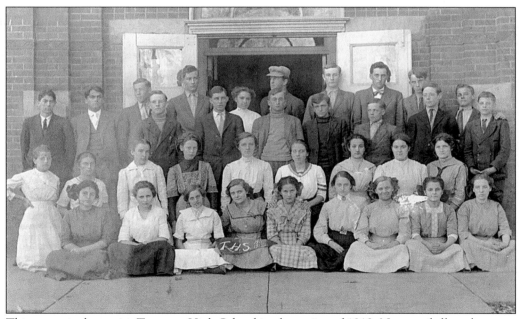

This group is the entire Tremont High School in the spring of 1912. Names of all students are on file at Tremont Historical Society Museum. The man with the cap is Principal Whetzel. The photograph was taken in front of the school building pictured on page 103.

Menert School was located in Sec. 27, Tremont Township. This brick building was built in 1916; the name Menert was given at that time as the location was near Menert Station and Elevator. A frame school, known as Vawter School, earlier stood on the same site. Menert School was closed in 1953 and students transferred to the Consolidated District School in the village. The building was later used as a private residence.

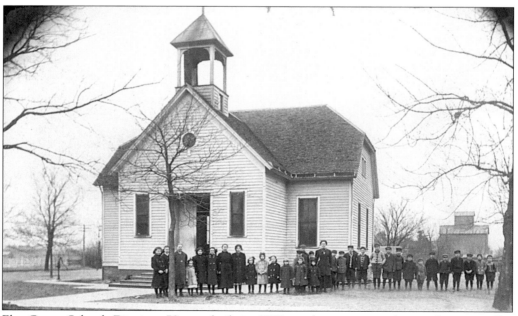

Elm Grove School, District #73, was built in 1897 on the same site where a former smaller school built in 1850 once stood. Glenna Barkdoll Goodyear was the teacher in this 1908 photo. The building still stands at 217 West Walnut Street, and after extensive remodeling has been used by several families as a private residence.

Eleven

GET ME TO THE CHURCH ON TIME

The Methodist congregation in Tremont was organized in the spring of 1891. This 1913 card shows the Methodist Episcopal Church building, which was dedicated Christmas day 1904. My grandfather James S. Tunis carried mortar during construction of the red brick building. Reverend O.I. Truitt, who was pastor during the building process, departed almost immediately after the dedication to head a church in Rangoon, India. On March 29, 1940, during the pastorate of Reverend Selden Myers, the church was extensively damaged by a fire, which started in the neighboring Beecham Grocery. Regularly scheduled services were held in the high school until restoration work was complete. The newly decorated church was rededicated July 14, 1940. The bell, which hangs in the belfry and is rung every Sunday morning, was a gift from the local Congregational Church, which disbanded about the same time the Methodist Church was being built. The bell, cast by the McNeneely Foundry in Troy, N.Y., in 1850, had been used for 54 years by the Congregationalists. (C.U. Williams #1880.)

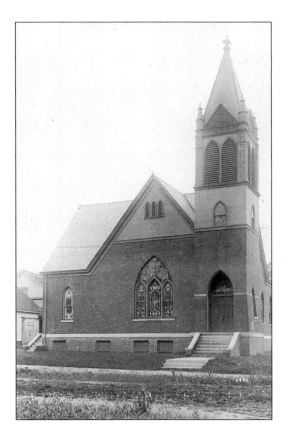

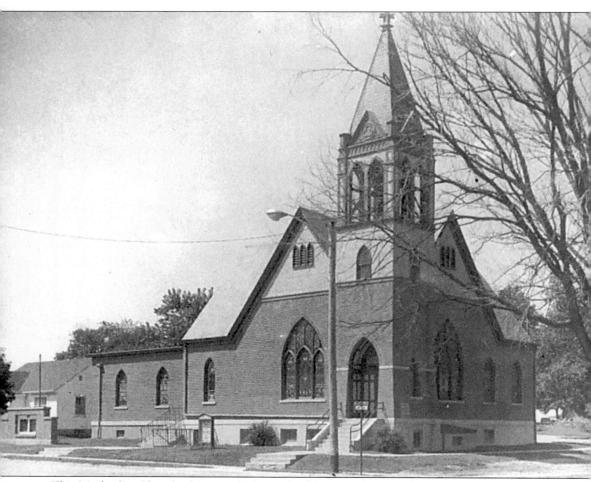

This Methodist Church photograph shows the $30,000 educational wing added in 1953 to the south of the original structure. Construction began mid-1984 on the addition to the west (not shown), which provided a much needed modern kitchen, fellowship hall, and more classrooms. In the fall of 1989 the Church Child Care Center was opened as a mission of the church. The nonprofit center has over 100 children enrolled. "Episcopal" was dropped from the name in 1939 as a result of a merger with other Methodist bodies. The present name, Tremont United Methodist Church, was first used in 1968. Monetary gifts from Andrew Carnegie, W.L. Pratt, Mary F. Kellogg, and others in 1912 made it possible for the church to install a seven rank Hinners tracker action organ. In 1965 a new Reisner organ console with improved accessories was installed and seven additional ranks of pipes were added at that time. It has been my privilege to serve the church as organist since 1955. The Gerald Beecham residence is visible at the left (south).

Construction was begun in 1909 on this Apostolic Christian Church. It stood in the 400 Block, South Chestnut Street and was first used for services in 1910. This was the congregation's third church building. The church cemetery is located directly east of this building site. The Apostolic Christian congregation in Tremont was established in the early 1850s. The first church building was erected in 1870 a short distance southwest of town a bit north of the Dillon Cemetery. The group previously met in members' homes. It is recorded that baptisms were conducted in nearby Dillon Creek. By 1881, the membership numbered nearly 200 and a larger house of worship was needed. A new church was built on the Kasper Koch farm one and one-half miles south of the village. A boardwalk was constructed from town to the church for those who had to walk to meetings.

Construction was started in 1962 on this present-day Apostolic Christian Church building at the corner of Franklin and South Chestnut Streets. Willis Sauder was chairman of the building committee. The Tremont Historical Society Museum has in its archives a printed program for the dedication, which was held September 8, 1963, for the $340,000 structure. A fellowship hall was added to the south in 1977.

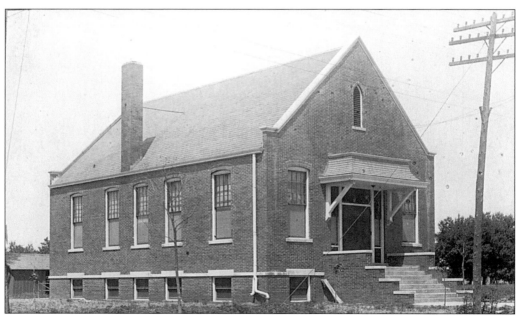

This Tremont Apostolic Christian Church was built in 1908 at the corner of South and Harris Streets. The founders parted from an earlier congregation to establish the new church. The building was razed in 1968, and a new church built on the same site was dedicated in October of that year. At this writing in 1999 the congregation once again needs larger quarters and plans are being considered for another church building. (C.U. Williams #12517.)

St. Patrick's Catholic Church was built in 1880 and the first Mass was celebrated on Christmas Morn of that year. The church was located in the 200 Block, East Washington Street and was razed c. 1930. There has not been a Catholic church in Tremont since that time. (C.U. Williams #1885.)

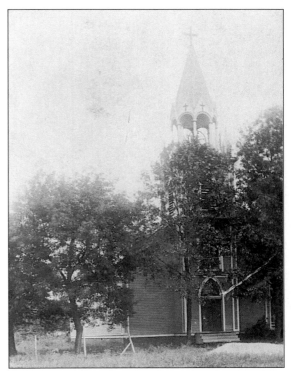

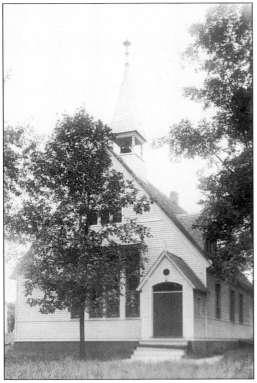

The first church (or meeting house as it was called) in the Tremont settlement was erected by the Baptists in 1842. The building pictured is the second Tremont Baptist Church, which was built in 1882. The wooden structure stood a bit north of the present-day church. (C.U. Williams #1881.)

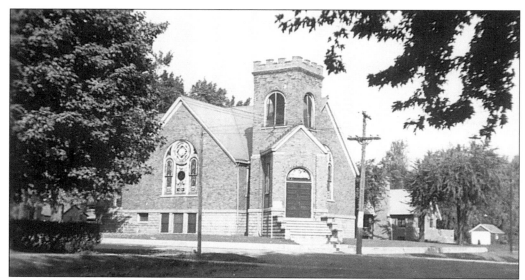

The cornerstone for this Baptist church was laid October 30, 1912, during Reverend E.L. Krumreig's pastorate. The Tremont Historical Society has in its archives one of the printed programs for the dedication service held April 20, 1913. This was the third church building built by the Tremont Baptist congregation. This card was sent to my grandparents, Mr. and Mrs. H.A. Nieukirk, as an invitation to the church's Centennial Sunday services in 1942.

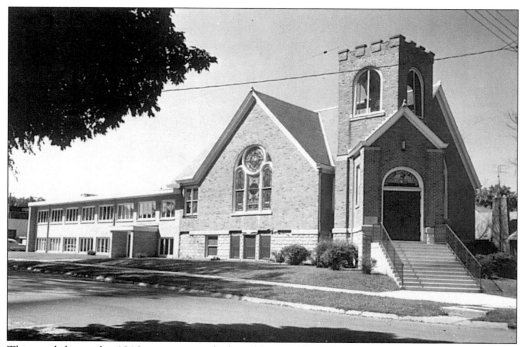

This card shows the 1912 structure with the addition of an educational unit completed in 1953. This building, after another substantial addition in 1993, is the current church home for the Baptist congregation in Tremont, which remains a strong presence in the community.

Twelve

NOBODY KNOWS THE TROUBLE I'VE SEEN

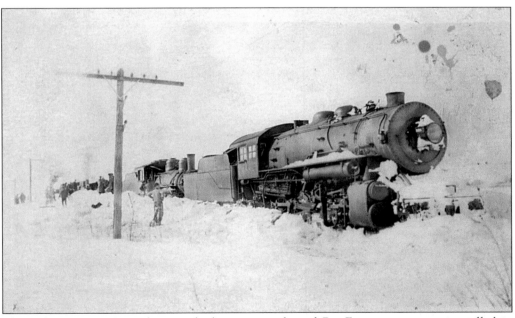

This February 24, 1914, photograph shows an eastbound Big Four passenger train stalled in snow near Leslie Station a short distance west of Tremont. The *Peoria Star* reported the train, made up of five or six coaches, left Peoria early evening on the 23rd. It was powered by three engines in anticipation of trouble with drifted snow. Nonetheless, it became stuck and the report tells that 40 stranded passengers were transported by bobsled to the Michael and Magdalena Maurer farm home, where they were housed and fed for two days. The train was finally freed as extra engines were dispatched with gangs of shovelers. Harold and Leslie Maurer, former Tremont residents, confirmed this story to me. They helped with the big shoveling job.

This card is reminiscent of the troubles encountered on early roadways. In August 1928, the first paved road through Tremont, running generally east and west, was opened as State Route #164. Prior to that time the roadway was either mud or dust depending on the whims of Mother Nature. The paved highway was redesignated as State Route #9 in 1938 and is still so known today. It follows a more direct path through the village than did the earlier route.

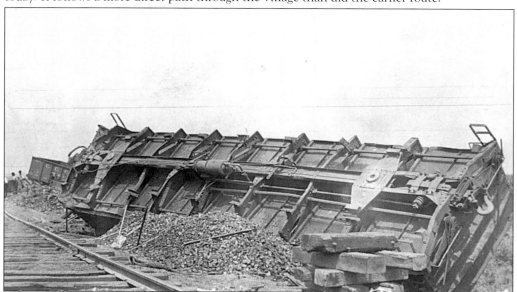

This train wreck occurred around noon July 25, 1915, on the Big Four route midway between Pekin and Tremont at a spot referred to as "schoolhouse hill." Nine cars, all loaded with coal, were derailed and track was damaged for at least one-half mile. No injuries were reported. The letters C.C.C. can be seen at far left. They stand for Cleveland, Cincinnati, Chicago, and St. Louis Railway, commonly known as the Big Four.

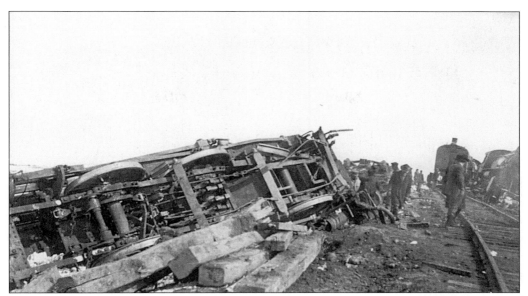

Each of the cards on this page has a penned notation on the back reading, "train wreck at Tremont." One cannot be certain if that is fact or merely someone's assumption. Regrettably there is no indication as to date or exact location of the derailment.

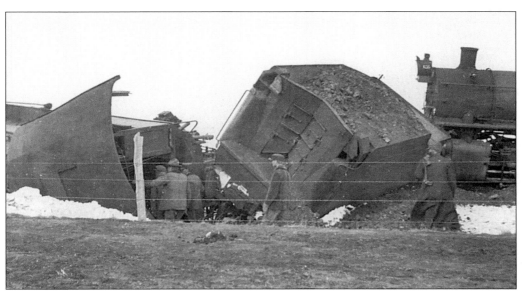

The pictures are not from the same accident as shown on the opposite page because the men in this photo are not dressed for July weather. Observers in the other photo are in shortsleeves.

Tremont's first automobile wreck, at least the first photographed one, is shown on these two cards. The license plate fixes the year as 1916.

The vehicles, an Oldsmobile and a Studebaker, were driven by former Tremont residents Louis B. Snider and Dean A. Stormer.

Thirteen

HOME, SWEET HOME

Anyone who has ever called Tremont "Home Sweet Home" will recognize this picture instantly. "The Barefoot Boy," subject of Whittier's poem, is depicted in this statue, which stands in the village park. Originally a water fountain, the work of art was designed and sculpted by Tremont native Miss Viola Norman. Unveiling and dedication ceremonies took place Sunday, November 7, 1915, with local and county dignitaries participating. Miss Norman, born in Tremont in 1889, studied and later taught at the Chicago Art Institute. She later founded her own Chicago School of Sculpture. She received many prestigious awards for her work, but alas, her illustrious career was cut short by death at age 46. Interment was in local Mt. Hope Cemetery. Miss Norman's benefactress, Miss Nettie Washburn, made it possible for her to study in Chicago and donated this sculpture to the village.

These sisters from "Home Sweet Home" are dressed in the style popular *c.* 1915–1917. Notice the large bows used as accessories. Standing is my mother, Mable Tunis Nieukirk; seated is Lenora Tunis Shane.

Summertime styles, I guess! Myrtle Altine Devore (referred to on page 101) is standing at right. Aunt Nora is seated in the same chair as shown above at Novelty Photo Studio, 502 1/2 South Adams Street, Peoria, Illinois.

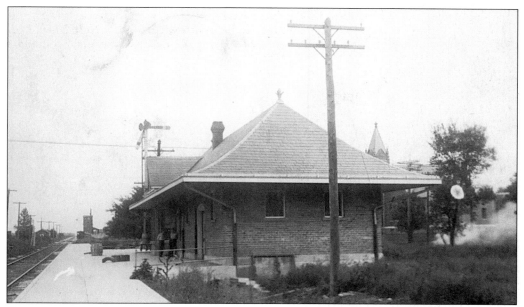

Tremont's Big Four Depot was built on Pearl Street in 1907 by the Peoria and Eastern Railroad, a division of the Cleveland, Cincinnati, Chicago, and St. Louis Railroad, known as the Big Four. At one time there were seven passenger trains and several freight trains passing through Tremont daily. This station with its Western Union office was the village's primary contact with the outside world. (C.U. Williams #1881.)

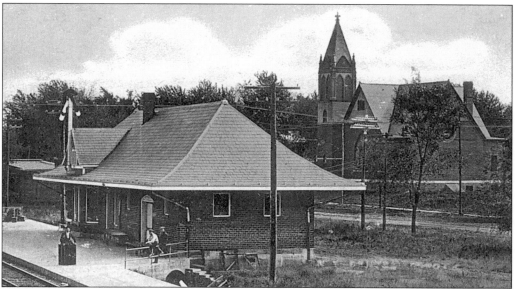

The last passenger train passed through Tremont October 23, 1957. In 1975 the Conrail System took over the depot. The tracks were removed in November 1985. The building is currently owned by the Tremont Lumber Co. and an addition to the west in a complimentary architectural design is currently underway. The Methodist Church can be seen in the background across Pearl Street. This 1915 card was printed in Germany for distribution by Frank A. Blue, who was Tremont's druggist from 1908 until his death in 1948.

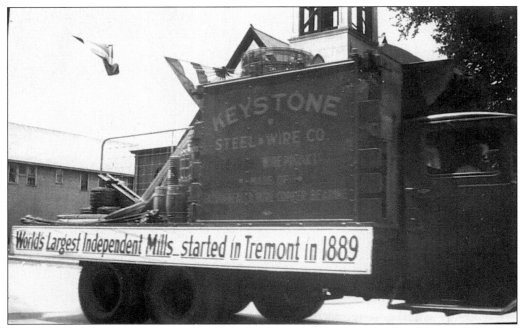

Tremont's centennial celebration was held August 2, 1935. This and the next two cards are from the Grand Centennial Parade. Shown here is the parade entry of Keystone Steel and Wire Co., which began wire fence production in Tremont in 1889. The wire mill was moved from Tremont in 1895 and now products are shipped to an international market from a Bartonville, Illinois facility.

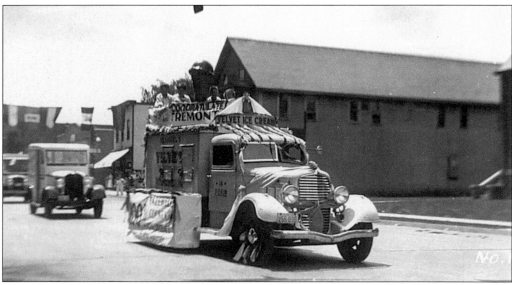

This card shows the Grand Centennial Parade entry of Soldwedel's Dairy in Pekin. The large building in the background is Hugh Giltner's general merchandise store. The Tremont Historical Society Museum has on permanent display a series of 20 some postcards of the centennial parade and celebration.

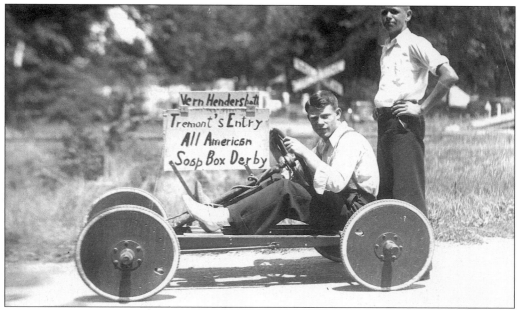

This card shows Vern Hendershott at the wheel of his Soap Box Derby entry as it appeared in the Grand Centennial Parade. Orville Weeks is standing nearby. Centennial entertainment besides the parade included the Pekin Municipal Band and WLS Chicago Radio artists including the "Hoosier Sod Busters." The special day's activities also featured a picnic, an historical pageant, balloon ascensions, parachute jumps, a baseball game, and a dance.

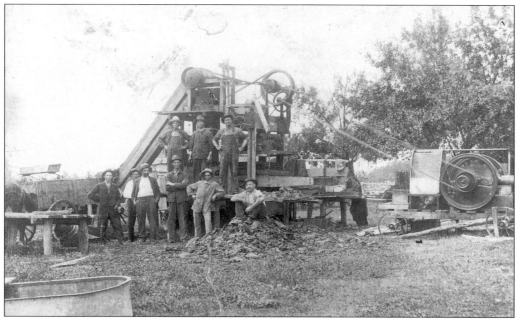

This cider mill was on the Joe Oertle farm 5 miles south of Tremont. Men standing on the platform are identified from left to right as Joe Lehman, Joe Oertle, and Cleo Stem. The card is from c. 1916. (Courtesy of Ben Oertle.)

I've been asked when showing this greeting card, "Is she from Tremont?" I think not; I'm sure I would have remembered her! She's pure fantasy!

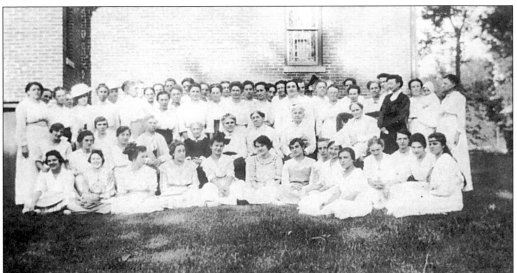

This c. 1915 card shows some real Tremont women, the ladies of the Methodist church, gathered on the church lawn. Pictured from left to right are (first row) #2 Clarice Barton, #4 Lenora Tunis Shane, #5 Anna Riggs Rapp, #7 Imo Stegner, #8 Mable Tunis Nieukirk, and #11 Louise Papenhause Luft; (second row) #2 Thelma Stegner Rickett, #2 Berniece Barton, #7 Julia Hayward, #8 Esther Washburn, #9 Mrs. Geo. Hayward, and #10 Mary Kellogg (in wicker wheelchair). In the back row Marietta Morse and Mary Elizabeth Hodgson Gearen have been identified. Others are unknown.

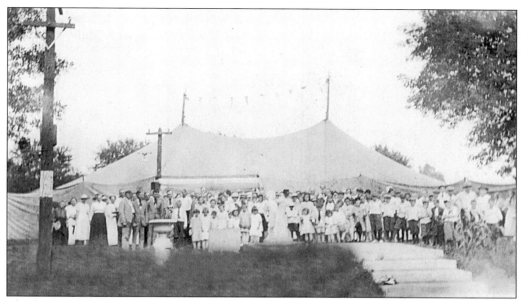

The large tent was in the village park for a Chautauqua meeting. The Norman/Washburn statue, front and center, offers a clue as to date. It was dedicated November 1915.

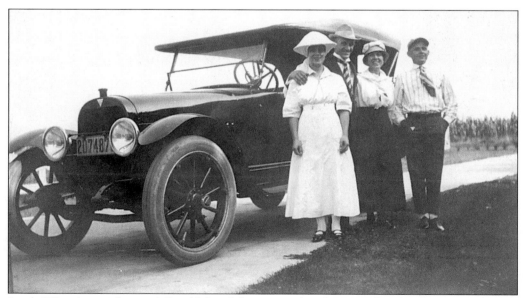

Jacob Winzeler, nicknamed Bumblebee Jake, is standing between his daughters Minnie and Louise. Son Joe is at left. A notation on the back tells the photograph is from 1916. The automobile is a Hudson, distinguishable by the small white triangle symbol. See pages 90 and 91 for photographs of the Winzeler farmhome.

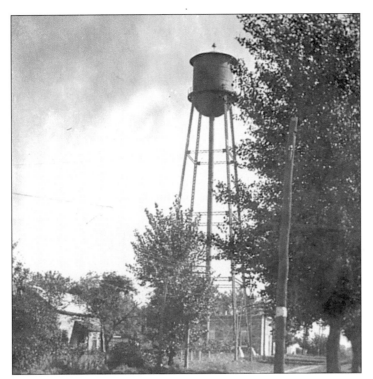

Tremont's first water plant began operations in 1911 with this pump station and the adjacent tower, which supported a 40,000-gallon reservoir. The red brick building still stands in the 100 Block, West Madison Street, and is used by the village for storage. For a time the building was used as a fire house. The George Eimen home, which was demolished in 1978 to make way for expansion of Davis Mortuary, is visible to the left (west).

A NIGHT SCENE IN
TREMONT, ILL.

Anyone who has ever called Tremont home knows for sure that the artist of this card never spent many nights in Tremont. Hannah posted this card to Lena on October 7, 1913. Tremont had several Hannahs in 1913, so we can only guess at the sender's identity.

126

INDEX OF PEKIN CARDS

INDEX OF TREMONT CARDS